MURALS Creating an Environment

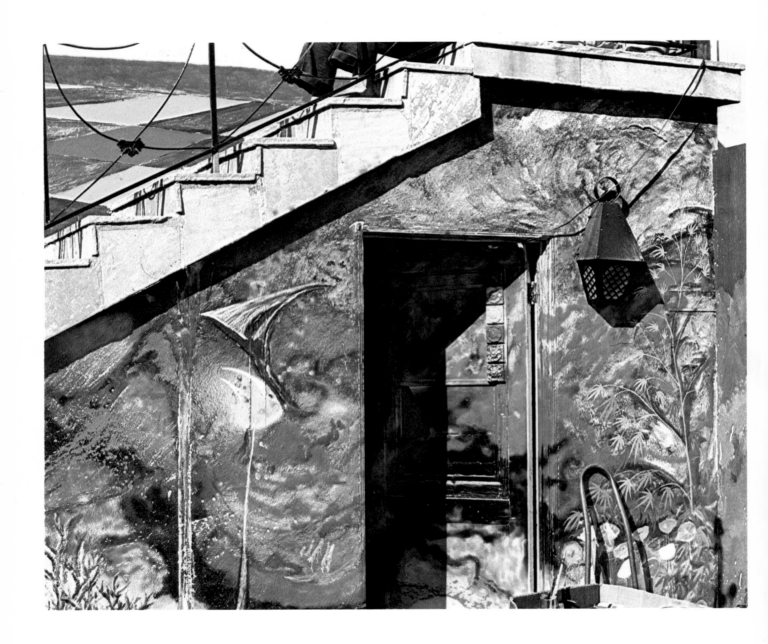

The entrance to a restaurant in Santa Monica, California.

MURALS Creating an Environment

Mary Korstad Mueller

With photographic assistance of **Ted G. Pollock**

Davis Publications, Inc.
Worcester, Massachusetts

This book is dedicated to all who have devoted their lives to helping children become enriched through art, and especially to the memory of J. Mansel Willett, former president of the California Art Education Association and art education ambassador extraordinary.

Copyright 1979
Davis Publications, Inc.
Worcester, Massachusetts, U.S.A.

Printed in the United States of America
Library of Congress Catalog Card Number: 78-72192
ISBN: 0-87192-106-5

Composition: J. S. McCarthy, Inc.
Printing and Binding: Worzalla Publishing Co.
Type: Helios Light and Bauhaus Demi Bold
Graphic Design: Jane Pitts

Consulting Editors: George F. Horn, Sarita R. Rainey

10 9 8 7 6 5 4 3 2 1

Contents

Acknowledgments

Any book is the result of learning that comes from human contact and personal experience. From my mother, Dr. Mary G. Korstad, I learned that creative work can be the source of much happiness; from my junior high school art teacher, Ethel Helen Outwater, I discovered the magic of the visual arts; from my late husband, Paul, the challenge of refining ideas; and from my daughter, Erica, the joy of words. To all of them I am deeply grateful.

My deep appreciation goes to the many stimulating teachers I have worked with, especially to Bruce and Claudia Hebron, Bob Rhoades, and Nancy Dunn who have made enthusiastic contributions to the mural environment. I extend sincere thanks to Pauline James, art specialist for the Los Angeles Unified City School District, for graciously taking the time to critique portions of the manuscript, to Paul Wiseman for his quiet encouragement, and to Gerald Brommer for his wise counsel. I am grateful to Kathy Dempsey and to Evelyn Goode for their efficient typing.

As in all situations involving selectivity, there are many murals of excellent quality not included in this book. Those chosen represent specific examples that illustrate the text. The cooperation of educators, artists, and directors in permitting the photographing and use of these works is sincerely appreciated. Photographs, unless otherwise credited, are by the author.

Above all, I want to thank the many children and students of all ages I have worked with during the past several decades who have made this book possible.

M.K.M

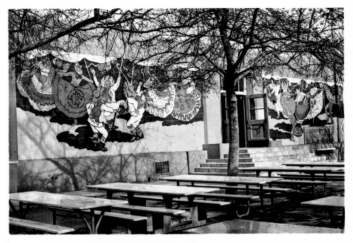

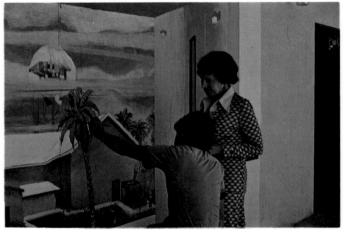

(Top)
A mural designed by Goez Studio especially for a neighboring school in a Mexican-American community of East Los Angeles.

(Bottom)
Evaluation is a necessary part of the process of mural making.
Courtesy of Bakersfield City School District

MURALS Creating an Environment

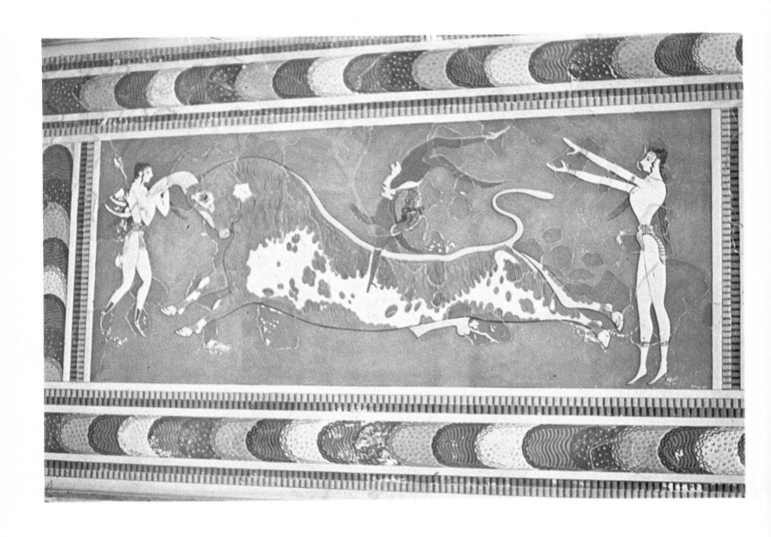

A fresco from the Palace of Knossos, on the island of Crete painted approximately 1500 B.C., depicts the ritual of bull dancing.

Chapter One

The Roots are Deep

The idea of painting walls is not new. It began when cave people grabbed charred sticks from their fires to draw with great sweeping strokes on the walls of their caves. The drawings of animals and hunters could have been religious symbols, or simply tribal records. We are not certain of their intent, but these drawings definitely created a new environment for those cave dwellers who lived possibly twenty-thousand years ago. And as wall paintings, they were murals.

Almost fifteen-thousand years later and approximately three-thousand years before the birth of Christ, the ancient Egyptians also decorated walls, constructing elaborate tombs as a suitable place for their honored dead. Earthly activities of the dead pharoahs and nobles were recorded in murals on the tombs' walls showing domestic life, hunting and fishing scenes, and the harvesting of crops by slaves. That the records of such vigorous living should come to us as a result of the Egyptian preoccupation with death seems strange. By leaving images, both carved and painted, in lavish graves, these ancient people felt assured of a life in the hereafter.

During much of the same period—but in direct contrast to the Egyptians—the Babylonians and Cretans showed more concern with life on earth. Their artisans decorated walls of palaces rather than tombs. The first known frescoes (a process of applying pigment to wet plaster) appeared in the Palace of Knossos on the island of Crete around 1500 B.C. These were animated paintings of musicians and dancers performing with bulls. There is a different tone to the more stylized relief designs of the later Assyrians that centered around the exploits of their kings while hunting or in battle. By 600 B.C., the Grecian influence became quite apparent as it spread from the homeland to much of the known world. Painted bas-reliefs on pediments and friezes of Greek temples portrayed gods' and goddesses' activities or the triumphant feats of heroes. The Romans, who followed the Greeks, borrowed many of the latter's ideas for their palace and villa walls, adding pictures of gamblers, musicians, and entertaining garden scenes. Mosaics created into interesting, worldly designs were reserved primarily for floors at this time.

A change in attitude occurred with the art of the early Christians. Their murals in catacombs and churches were of a holy nature, visually relating the life of Jesus and His disciples, or

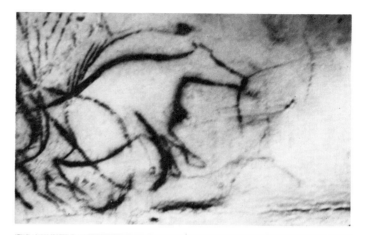

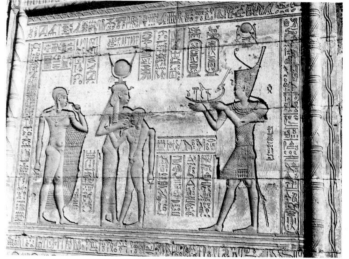

1

(Top)
A bison drawn approximately twenty-thousand years ago on a wall in the caves of Pech Merle in Southern France.

(Bottom)
Immortality was assured the Egyptian monarchs through likenesses carved or painted on the walls of their tombs. Photograph courtesy of Air France

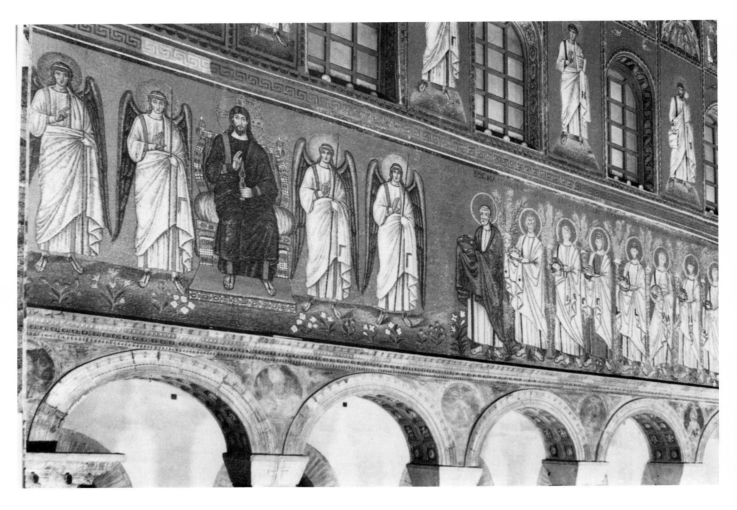

Sixth-century mosaic on the wall of the church of Sant' Appollinare Nuovo in Ravenna, Italy. Photograph courtesy of Gerald Brommer

martyrs and characters from the Old Testament. The technique of applying tiny pieces of glass and marble on walls to form mosaic pictures of brilliant quality became popular during this era. Almost simultaneously, the intricate culture of the Mayans in Central America was reaching its height. The Mayans' art forms also were related to their religion. Carvings of gods, in compactly composed relief designs, were intertwined with abstract symbols. Mayans wanted to show all of the characteristics of their gods, religiously and formally, on the walls of their temples and sacred buildings.

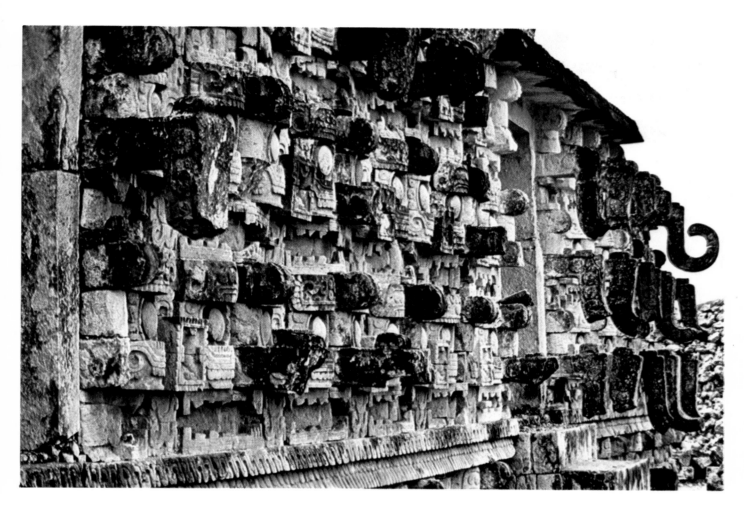

A carved Mayan wall in Chichen Itza, Mexico. Photograph courtesy of Al Dennis

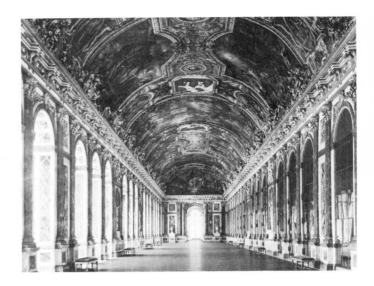

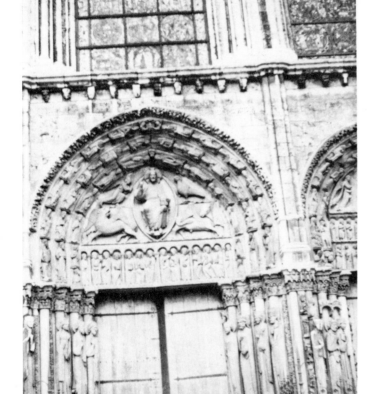

(Above)
The tympanum above the main portal of Chartres Cathedral shows Christ surrounded by symbols of the four evangelists. It is an example of twelfth-century French Gothic architecture.

(Right)
Versailles, in France, was built for Louis XIV in the seventeenth century. Its beautiful Hall of Mirrors, decorated by Carles Le Brun, has a ceiling covered by murals. Photograph courtesy of the French Government Tourist Office

During the Middle Ages, the art of the devout reached a peak. Bible stories were carved, painted, or formed into mosaics and sparkling panes of colored glass on the interiors and facades of European churches. Tympanums (the triangular spaces in the arches above church doors) and other areas vividly advertised the glories of virtue, showing figures of the saintly moving toward the enthroned Christ in heaven, while the sinners, in chains, were being led away to hell. These works of art served as giant picture storybooks for the nonreaders and the uneducated to teach them about Christianity and, it was hoped, to bring them into the fold of the church.

As time passed, allegories, myths, the lives of saints and deeds of valor—especially those of reigning monarchs—became popular subjects for ceilings and walls of religious buildings, palaces, and great halls. The idea later caught on with merchants and townspeople. They began decorating the outside walls of their places of business and homes, especially in Southern Germany, Austria, and Switzerland. These were permanent statements for all to see and to enjoy.

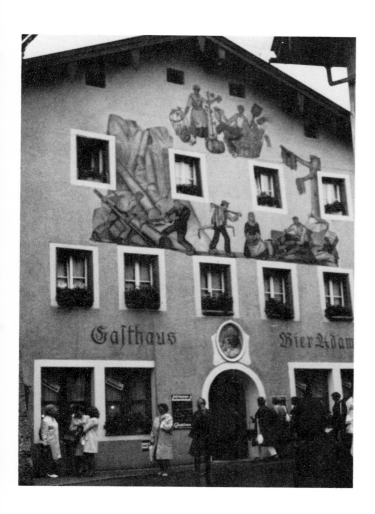

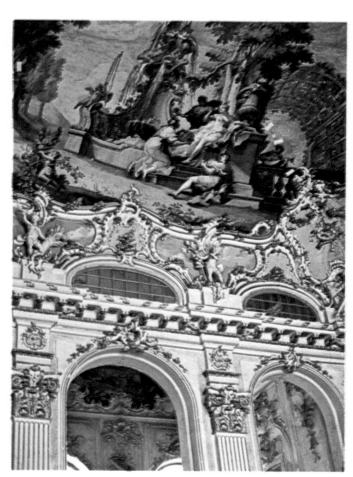

(Above)
Painted murals are an important part of the decoration in the baroque Nymphenberg Castle of Munich, Federal Republic of Germany. Photograph courtesy of Gerald Brommer

(Left)
The painted facade of a guest house in Berchtesgaden, Federal Republic of Germany.

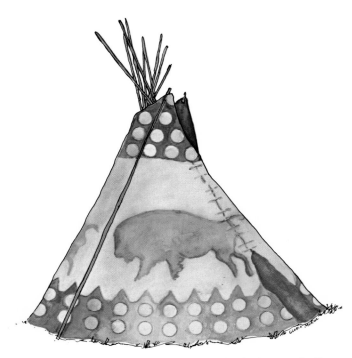

A buffalo-hide tipi of a Blackfoot American Indian is decorated with two buffalo and geometric symbols of stars in the sky. Reproduction painted by Gloria Muñoz, of American Indian descent.

Spanish explorers of the New World in the sixteenth century described another type of exterior home decoration. This was the wide-spread custom the American Plains Indians developed of painting the rawhide exteriors of their tipis. Most were decorated with horizontal bands of geometric designs at their top and base. The area in between frequently was reserved for pictographs that related to the dreams and exploits of the owner. Rawhide linings of the tipi interiors were also painted, often in the same fashion as the exteriors. Earth-tone colors of reds, browns, and yellows were used along with blue and black. The reported communities of as many as fifty tipis in one area must have been a colorful sight to these early Spanish adventurers. Indian tribes in the Plains area that extended west of the Mississippi River continued this style of home decorating through much of the nineteenth century.

Eventually, the arts became more mobile. Framed pictures that could be transported easily from place to place, an impossibility with wall art, came to be strongly preferred. But even though their popularity at times seemed to wane, murals remained on the scene.

In 1910, after the fall of the Mexican Government under the leadership of Porfirio Diaz, murals regained recognition as a means of making a strong, visual statement. The Mexican artists of this period revolted against traditional, academic styles, and strove to develop realistic paintings showing social concerns that were more relevant to their times. Within a decade, the new government had commissioned artists to cover the walls of government buildings with murals that frequently displayed themes of suffering and revolutionary struggle. Such giants as José Clemente Orozco, Diego Rivera, and David Alfaro Siqueiros led the way to a brilliant and powerful expression of Mexican heritage that changed the style of their country's painting.

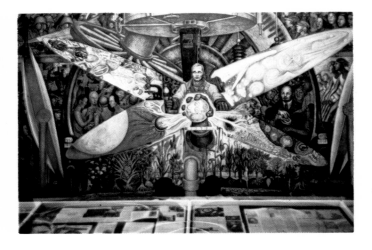

(Left)
A strong social statement has been made by Diego Rivera in his mural in the Palace of Fine Arts, Mexico City. Photograph courtesy of Gerald Brommer

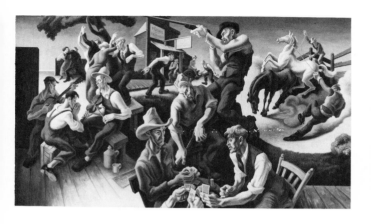

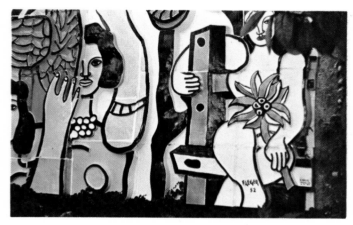

(Above)
Arts of the West, *one of a series of murals depicting the Arts of Life in America by Thomas Hart Benton. Tempera. Courtesy of the New Britain Museum of American Art, New Britain, Connecticut (Harriet Russell Stanley Fund). Photograph by E. Irving Blomstrann*

(Right)
Glazed ceramic tiles form a mural by Fernand Léger for the Golden Pigeon Restaurant in St. Paul de Vence, France.

During the 1930s, Orozco and Rivera were invited to paint important murals in the United States. These two artists strongly influenced American painters during the Great Depression. Financed by the government's Works Progress Administration (WPA), many artists were given needed employment to paint scenes on the walls of public buildings, adding color and life to previously cold and bare areas. Some used social themes and city life for subject matter, while others chose to develop their work around the idea of the American Scene. Grant Wood and Thomas Hart Benton were two artists who turned to the praise and celebration of America in their work. They used the Midwestern farmers and their land for inspiration. But all of them helped to change an environment as a result of their creativity.

With the advent of abstract expressionism and action painting after World War II, artists began working on huge canvases, many with the dimensions of earlier murals. Jackson Pollock, Willem de Kooning, Robert Motherwell, and Clyfford Still were among the leaders of this movement. The popularity of paintings that covered such large areas seemed to lead naturally to a revived interest in wall paintings. Architects of modern, commercial, industrial, religious, and even residential constructions incorporated mural designs into their plans. All media were used, including wood, frescoes, mosaics, cast or welded metal, plastics, enamel, ceramics, fiber, and luminous stained glass. Interior decorators, realizing the environmental impact of murals, helped to create a demand for inexpensive wallpaper murals that came within the reach of the average householder's budget.

The story of the Westward Movement in America unfolds in a mural at the American Airlines Terminal of Kennedy Airport in New York.

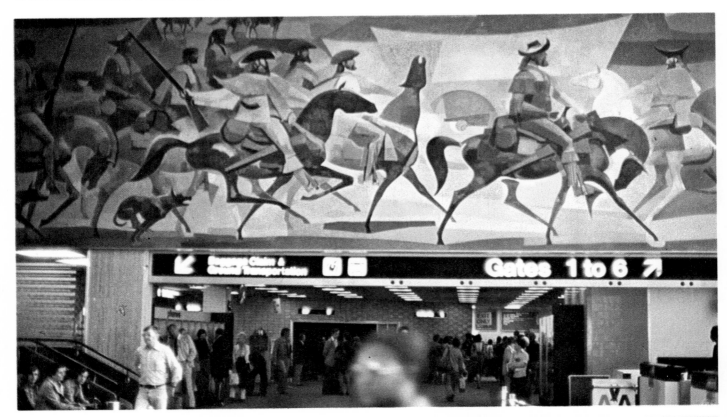

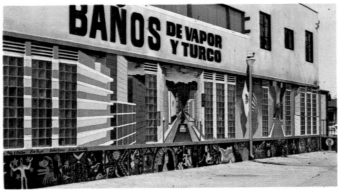

A store front in a Mexican-American neighborhood of East Los Angeles has been revitalized by an angular mural. The design creates an illusion that the flat surface is three-dimensional.

The dramatic flight of the Phoenix, rising from its own ashes, symbolizes rebirth, and thus new hope, on the end wall of a San Francisco housing development.

Perhaps the most startling aspect of the mural boom happened in the city streets during the 1970s. In attempting to cover unwanted graffiti and to revitalize deteriorating neighborhoods, colorful paintings appeared on housing-project exteriors, store fronts, garage doors, retaining walls, and freeway supportive structures. Some were financed by business patrons, others by government funds, and several by the artists themselves, who enjoyed the opportunity to advertise their talents and to make visual statements they felt were important. Ethnic groups painted historically significant pictures; others created vibrant, realistic, or abstract designs. The total environment of many communities was improved and changed.

The human need for self-expression is ageless. Although the written word can describe events, feelings, and ideas, readers must use their imaginations to visualize the author's meaning; however, imaginations vary. Murals can depict an artist's vision of his or her environment—either as it existed in life or as the artist saw it during his or her lifetime. The artist's conception of his or her society reaches through the centuries to provide information to succeeding generations that could not have been conveyed in any other way. Cultures may disappear, but the experiences and dreams of those who lived in the past continue to communicate to us through their surviving visual arts.

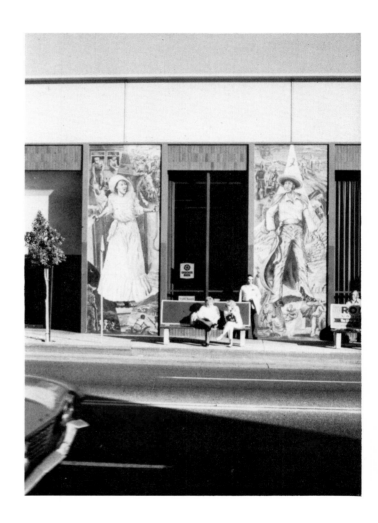

Part of a series of figure murals painted by a group of artists for the Los Angeles City mural program sponsored by the Parks and Recreation Department.

Chapter Two

Mural Materials

Because the choice of materials can determine the technique and structure of a work, a mural artist must select these materials carefully. Some media may permit more realism and detail. Others, because of certain limitations, demand a more abstract and broader rendering that encourages the viewer to use his or her imagination. He or she is urged to search for meanings found in simple clues of color and form.

Paints

Most murals are painted. Two essential ingredients are needed to produce paint. The first is pigment, which provides the color. Usually pigment is produced in powdered form. The second ingredient is the medium in which the color is suspended and which enables the concoction to be applied to and spread on a surface. Other materials may be added to hasten or to retard drying, or to add body or different qualities to the paint. But a pigment and a liquid medium are the two basic materials.

Early cave people possibly added color tints to their mural drawings, made by using burnt sticks. Perhaps the first paint was animal blood or berry juice daubed on a cave wall with bits of fur, a chewed stick, or a fluffy weed. Those who followed experimented to discover other natural pigment sources. Any parent who has encountered mud, grape juice, and grass stains on the clothing of a young child knows the coloring possibilities, and permanence, of some of nature's ingredients.

Artists have been exploring paint-making processes for thousands of years. The results of their efforts have appeared on painted walls of tombs and buildings from ancient Egypt to contemporary America. During the Renaissance in Italy, the processes were highly individualized—painstakingly developed by each artist, who jealously guarded his or her secret formulas from other artists. Unfortunately, when an artist died, the methods (with rare exceptions) died with him.

A popular paint during the Renaissance was tempera, in which egg was used. It was one of the mediums that was mixed with pigments to increase the adhesive quality of the paint. This made it possible for artists to paint on a wide variety of surfaces. Colors in some tempera paintings were so vivid that many believed they were created by adding pulverized precious gems to a binder. The brilliant colors appearing in some of the small paintings by the fifteenth-century artist Fra Angelico appear to justify such speculation. Although semiprecious stones, including the beautiful blue lapis lazuli, often were used, some hues were the result of less costly minerals, paints, and clever chemistry.

Oil paint began to appear during the Renaissance. Its invention has been attributed to the Flemish artists, the van Eycks, but there is evidence that others had experimented with it somewhat earlier. In the first half of the fifteenth century, however, Jan van Eyck is known to have perfected an oil paint and varnish of exceptional quality that enhanced and preserved the brilliance of colors. This made it possible for artists to create paintings with delicate detail and subtle light effects. Jan van Eyck's elegant pictures are a tribute to his artistic skill and to his inventive genius. Unlike brushes used with tempera, which has a water base, those used with an oil medium must be cleaned in gum turpentine or a similar solvent.

A water-soluble tempera-type paint known as casein can be made from an ingredient found in milk. When combined with pigments, it produces an excellent paint with a matte finish. Another tempera is made from calcimine carbonates and a filler. This type is used for school easel paints and poster colors, and has the pigment count loaded with soap to permit ease in washing out paint that has been spilled on clothing. Soap also makes paint spread more easily. These paints are somewhat less permanent than casein. The degree of permanence depends on the various additives, and the quality and kinds of ingredients used.

During the 1930s, the Mexican muralists began using a new synthetic paint known as polymer. Unlike traditional oils or watercolors made with natural resins, polymer paints consist of synthetic resins. Polymer paints are processed by suspending color with resin in an emulsion. When the paint is applied to a surface, the water in the emulsion evaporates, and the resin particles form a plastic film binding the pigment and particles together. Once hardened, this polymer film cannot be redissolved in water. Although water is used with this paint, brushes should be rinsed frequently during the painting process so that the paint will not have a chance to harden on them.

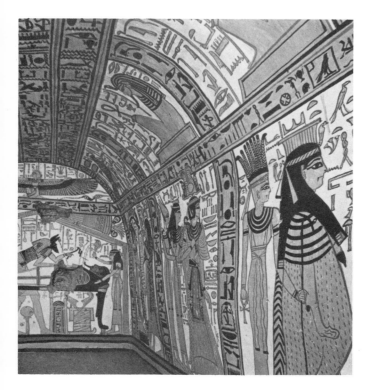

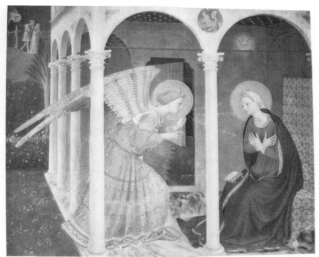

(Top, left)
An ancient Egyptian mural painted approximately three-thousand years ago. Photograph courtesy of Gerald Brommer

(Above)
A Roman fresco from the ruins of Pompeii. Photograph courtesy of Gerald Brommer

(Bottom, left)
Fra Angelico painted The Annunciation, a mural in the monastery of San Marco, Florence, Italy, during the fifteenth century. Photograph courtesy of Gerald Brommer

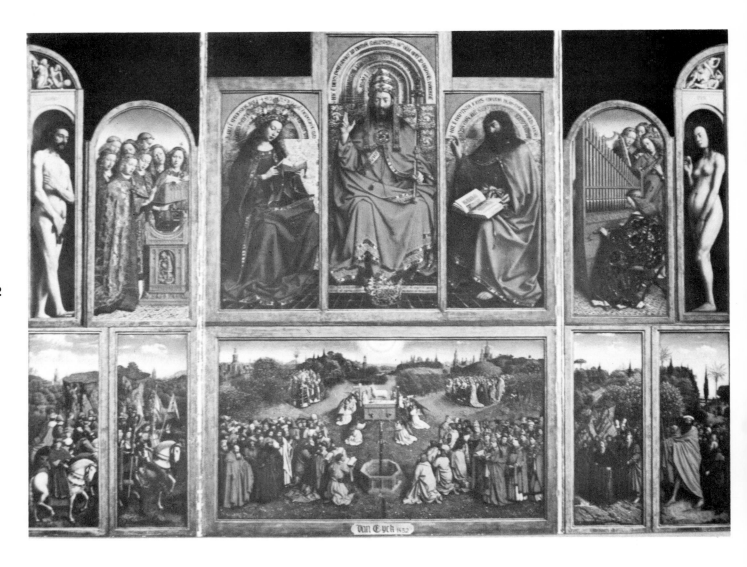

The famous van Eyck altarpiece was one of the first successful oil paintings. It is in the church of St. Bavo, Ghent, Belgium. Photograph courtesy of Gerald Brommer

Of the many types of polymer paints that have been developed, acrylic emulsions are the most successful, since they do not yellow or become brittle as others do. Any painter who uses polymers, however, should choose the same type of emulsion in all of the colors he or she needs. Mixing some hues of acrylic and others of copolymer emulsions, for example, is not advised because of their incompatibility. Also, if possible the same brand should be used throughout a project. Mixing different formulas may cause unwanted chemical reactions that could result in a disappointing end product.

Because polymers have many advantages over traditional types of paint, they have become a favorite among a large group of artists. They are fast drying, easy to apply, nearly fadeproof, adhesive, flexible, fairly inexpensive, impervious to weather, and have brilliant colors. And they are the most versatile of all paints. They can be used to create the visual effects of oil, watercolor, casein, tempera, gouache, or fresco. Also they can be employed for block printing, serigraphy, and textile design. Although all types of paint are being used today by artists, polymers have become very popular with muralists.

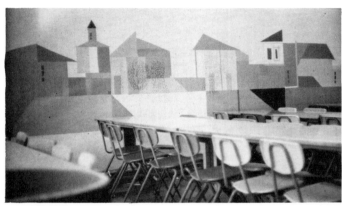

The versatility of acrylic paint, the most popular of several polymer paints, is demonstrated in this impasto painting by a high-school student. Courtesy of Lutheran High School, Los Angeles

(Top)
This mural of an abstract city by high-school students is one of many showing the popularity of acrylic paint. The design provides a pleasant environment for a school cafeteria. Courtesy of Los Angeles Unified School District

(Bottom)
Acrylic paints can be used to create the visual quality of watercolor. Courtesy of Los Angeles Unified School District

13

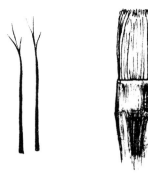

An individual bristle has multiple points and is usually made into flat, square-ended brushes. These fall into different categories for a variety of uses, but their composition is similar.

The individual hairs of furry animals are thinner at the root than at the belly, tapering to a single point at the top. Their most common use is for round, pointed brushes.

Brushes

Paints may be applied to a surface in many ways: by using brushes, rollers, sponges, painting knives, strips of leather, cardboard edges, spray guns, twigs, feathers, rags, or even hands and fingers. But brushes are the logical tool for most tasks.

A traditional brush is made from natural animal bristle or hair. Bristles come from the backs of hogs and boars. They are shaped differently from the hairs of furry animals and are stiffer. Thus they have different uses. A bristle has a unique taper—wide at the base and narrow at the tip—that ends in a split of multiple points called a flag. In making a bristle brush, as in all brushes, the tip of each bristle or hair must point in the same direction to hold and to spread paint properly. The working properties of a brush depend on this taper.

Hair brushes are made from many animals. As a class, they are distinctly different from bristle brushes. Each brush hair has a finely pointed tip, gradually swelling outward toward the mid-section or ''belly,'' before tapering down to a smaller thickness at the base. The pointed silhouette of a round hair brush is due to the natural taper of the hairs as they are bundled together with all tips pointing in the same direction.

The finest and most expensive of all hair brushes is the red sable. A less costly one is the camel-hair brush. But, strangely, neither of these two types has any relationship to the animal for which it is named. A red-sable brush usually is made from the best hair in the tail of the kolinsky, an Asiatic species of mink. The camel-hair brush is made from a careful selection of soft hairs processed from various animals to provide the greatest strength and elasticity, or snap, for its particular size. The source of its name remains a mystery, although it has been suggested that there might have been a Mr. Camel somewhere in the past who experimented with combinations of several types of animal hairs to produce a close copy of the favored red sable.

Other types of hair brushes are the black sable, made from the tails of wood and stone martens and the civet cat; strong and flexible ox hair, from the ears of oxen; fitch hair, from the tail of the Russian fitch or the North American skunk; badger hair, from the back of badgers found in Southern Russia or Turkey; squirrel hair, from a squirrel's tail; and goat hair, from the chin and back of goats. Very inexpensive brushes frequently are made from goat hair.

As with paints, brushes also are synthetically made. Nylon and other synthetic products provide quality bristle- and hair-brush likenesses. Depending on the artist's needs, they can be nearly as satisfactory as natural materials, although several artists may debate this point. A good brush, if given proper care, will last a long time. But it must be cleaned thoroughly, never soaked in water over a long period, and allowed to air dry after each use. A brush may be stored with the tip up and resting on the handle, hanging from a brush holder, or lying flat. Allowing it to rest on its hairs or bristles may cause permanent damage and should be avoided. Also, arrangements must be made for protection against moths and other insects if brushes made from natural materials are to be stored for any length of time. This is unnecessary for those made from synthetic material.

Brushes used for mural painting must be chosen for specific tasks. Wide brushes are best for covering large color areas, while smaller ones are more suitable for detail work. Different surfaces also require different types of brushes. Animal bristles do not hold up when used on rough materials, since they lose their flagging and wear out in a matter of hours. Synthetic brushes, however, will last for several days under the same conditions and will retain their flag tips, making them a better choice.

Another consideration in choosing brushes is their water absorption rate. If the absorption is too high, the brushes will have a tendency to go limp if in continuous use for over a thirty-minute period. A simple rule to remember is that animal bristles absorb 50 percent of their weight in water during a half-hour of painting, whereas nylon brushes absorb 15 percent, and the new synthetics absorb only 9 percent during the same time and under the same conditions. Because of their more lasting qualities and minimum absorption rate acrylic brushes have become popular with muralists. But animal hairs and bristles are superior for painting fine lines and details. It is difficult for synthetics to match them in these areas.

If help is needed in trying to paint out-of-reach areas, extensions such as broom handles, can be added to brushes and paint applicators.

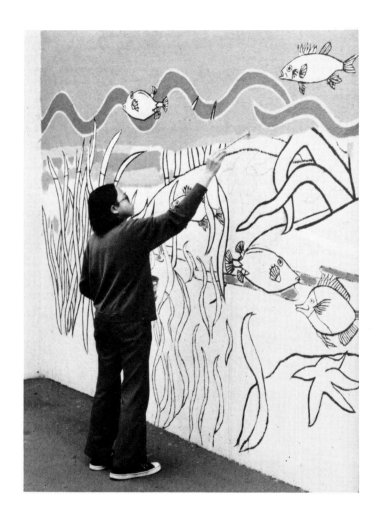

15

Smaller brushes are used for detail work. Courtesy of Santa Monica Unified School District

Detail of a 3' X 10' wax crayon mural by seventh- and eighth-grade students. Courtesy of Bakersfield City School District

Crayons and Chalk

Crayons and chalk should not be overlooked for mural making, but they have limitations. They are used to best advantage on paper or paper products, such as cardboard. The pointed ends of crayons usually are reserved for creating small-size pictures. Under some circumstances, and if time is not a concern, this method can also be used to create a large, colorful mural.

The latter process is slow and tedious, requiring patience from the artist. However, the brilliance of the colors and the surface quality can compensate for the amount of time involved. The broad stroke method, using crayons on their sides, permits the work on a mural to be completed more easily and quickly, but the richness of the colors as a consequence is somewhat diminished.

When crayons are used on paper, a padding, preferably of newspapers, should be used under the mural surface. It permits the crayons to glide smoothly, thereby helping to intensify the color. Cut and torn paper shapes and textured materials, such as burlap or corrugated cardboard, may be inserted beneath the picture paper to provide texture created by the crayon rubbing technique.

Chalk may be used in ways similar to the methods employed with crayons. The particular quality of this material, however, presents a problem of permanency. When covered with an acrylic medium or liquid starch, or if sprayed with a fixative it will be less likely to rub off than if used alone.

Cut or Torn Paper

Crayoned and painted designs, as well as construction paper figures may be cut or torn for use in making murals. Plain, colored paper is especially adaptable if unshaded areas or abstract, hard-edged forms are desired. A three-dimensional aspect may be achieved by curling, scoring, folding or bending paper, though the result may be a bit fragile unless strengthened by a paste or glue substance to make papier-mâché.

(Top)
Detail of a mural illustrating the importance of form and space arrangement in a torn-paper mural by fourth-grade students. Courtesy of Bakersfield City School District

(Right)
After a field trip to a local outdoor museum, junior high-school students translated their ideas into a unique mural (detail shown) made of built-up cardboard shapes outlined with heavy cord and painted with acrylic. The base is formed by two 4' X 8' wooden panels. Courtesy of Bakersfield City School District

Cardboard, both smooth surfaced and corrugated, can be used separately or combined with construction or other papers for surface variety. Heavier paper boards may be built up by layering one piece on top of another to form a sculptured relief. These can be sprayed with water-soluble enamel or brushed with acrylic paint to provide a lasting surface.

To add variety in the making of cut-paper murals, colored tissue paper, laminated in colorful overlays with liquid starch, white glue, or an acrylic medium, will provide an interesting technique. Pieces of fabric, found materials, and shapes cut from the colored pages of slick-paper magazines also may be used. These are recommended especially for variations in texture. Yarn of different weights, string, and wire can be effectively combined with any of these materials, and all are suitable for most classrooms.

Mosaics

A mosaic is a design created by fitting together small pieces of glass, marble, or stone. These pieces, called tesserae, are fastened to a wall or backing material that has been coated with wet cement or a strong adherent such as a pasty-textured mastic. Sometimes white glue is used to bond tesserae to a wooden backing. Spaces between the pieces may be filled with grout, which is made of thin mortar or fine plaster. The use of grout will depend on the visual quality preferred by the artist and is not essential to the permanence of the piece. Sometimes shadows caused by unfilled cracks enhance the design, especially if the tesserae are of varied thicknesses, providing an interesting three-dimensional effect.

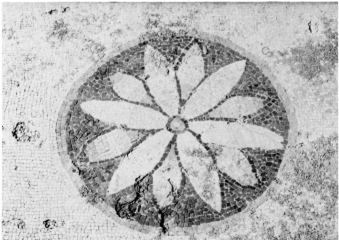

(Top)
Variety can be obtained by making a mural of layers of colored tissue paper laminated together on a firm surface. Details may be added with a brush or pen. Courtesy of Bakersfield City School District

(Left)
Abstract design of a pre-Christian mosaic from the Greek island of Delos.

The early Greeks and Romans used mosaics for floor decorations depicting people, animals, vegetation, or scenes. Abstract designs were also used, many of them appearing in rhythmic borders made of varicolored marble surrounding the central figures. Many excellent examples of mosaics can be found on walls and ceilings which were popular surfaces for their construction. Early Christian and Byzantine churches were covered with picture stories of the Bible rendered in colorful glass—and, occasionally, marble tesserae. Additional richness was achieved through the use of beaten gold, or gold leaf, fused between two small squares of glass less than an inch wide. This became a popular embellishment for Christian murals during the sixth century. The use of gold implied the glory of heaven in religious scenes. One of the most fascinating qualities of mosaics is the variety of moods provided by the gradual change of light reflecting off their surfaces throughout the hours and seasons.

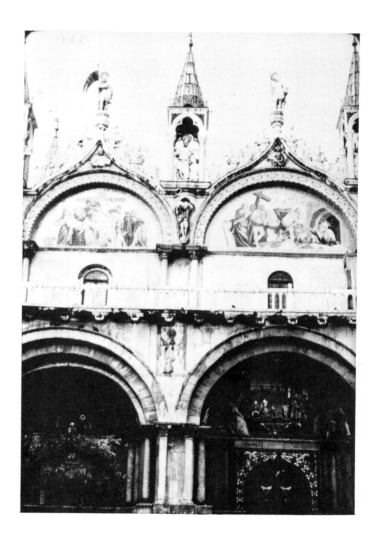

Mosaics dating from the seventeenth through the nineteenth centuries fill the lunettes above the main entrance to the eleventh-century Bascilica of San Marco in Venice. Photograph courtesy of Paul Wiseman

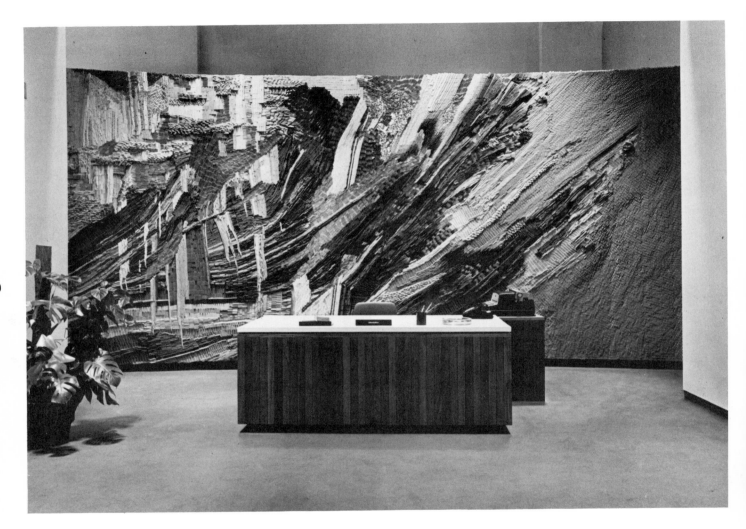

20

Tesserae of different sizes and thicknesses are combined to reflect light in an exciting, abstract, forty-foot glass mosaic mural by Glen Michaels for the interior of a Pennsylvania building. Central Penn National Bank, Philadelphia. Architect: Vincent C. Kling and Partners. Photograph courtesy of Lawrence S. Williams, Upper Darby, Pennsylvania

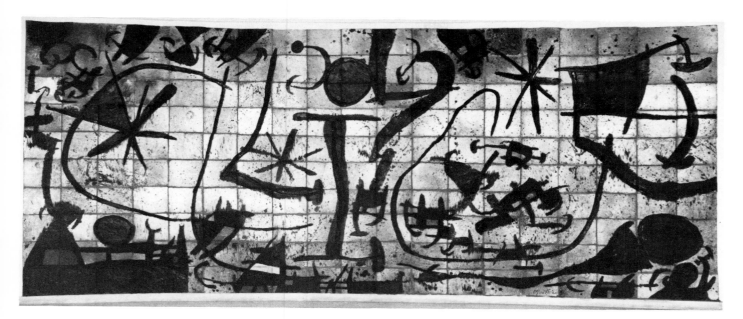

Although some of the artists who design mosaics carry their project through to completion by actually placing the tesserae on the wall, many give their scale drawings or paper cartoons to mosaic craftspeople who specialize in doing this type of work.

Mosaic murals may also be created with less traditional tesserae. Small pieces of wood, ceramics, plastic, linoleum, metal, assorted pebbles, waterproofed paper or cardboard, and different scrap articles can be used with equal success by young students or professional artists. Other more perishable media have met with some popularity in school classrooms due to availability, low cost, and ease of application. Eggshells, popcorn, macaroni or pasta, and small puffs of colored tissue paper are among these. But if they are to be employed in the making of a mural, both teacher and students should determine whether the fragile quality and final effect justify the time and effort involved.

Squares of colorful mosaic tile are worked into a striking mural by Joan Miró and Joseph Lorens Artigas for the first-level ramp of the Solomon R. Guggenheim Museum as a memorial to Alicia Patterson Guggenheim. Gift of Harry F. Guggenheim. Courtesy of The Solomon R. Guggenheim Museum, New York

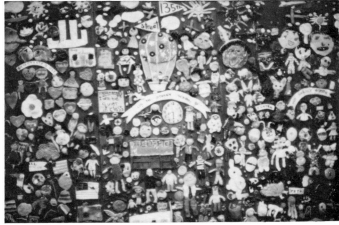

(Top)
Barbara Ford created textured square ceramic tiles within free-form sections to make an attractive wall for the Pittsburgh National Bank Building. Courtesy of Associated Photographers, Inc., Pittsburgh, Pennsylvania. Photograph by Dick Brehl

(Bottom)
Hundreds of school children contributed to this baker's dough mural, of which a detailed portion is shown. Students individually created figures, faces, animals, and designs that were baked, painted, and mounted on a wooden surface. Courtesy of Los Angeles Unified School District

Tesserae may vary in size from approximately one inch to pieces of six inches or more. And the shapes can differ from geometric to free form. If large pieces are chosen, their character can be altered by decorations that are incised, built up, or painted. This provides more leeway, with pictures forming within the picture to make a collection of ideas that can enhance the final impression. Ceramic clay, baker's dough, enameled copper, wood sections that are carved or appliqued, layered thicknesses of cardboard, and cut or torn paper all work well for mosaic-type murals. These materials are suggested for unusually large tesserae.

Professional artists often place the tesserae, or arrange to have it placed, directly on the wall. This process may not be best for most students unless the area selected for the design is easily accessible. A simpler way is to adhere the small segments to a strong surface such as plywood or Masonite with a good mastic. When completed, the board may be attached to a wall for permanence.

Other Materials

Murals can be fabricated from many different materials that can be used in numerous ways. They may, of course, be carved from stone, as in the marble Parthenon of Athens and other excellent examples that have come to us from the past. The difficulty of the task, the technical skill required, and the time involved have caused modern artists to search for other ways to express their ideas. Cast concrete has been a type of substitute, but cannot replace the beautiful quality of carved stone. Ceramic clay may be worked into one or more large slabs that can be bisque fired or highly glazed to become a complete mural. Metal may be cut, formed, or welded to cover large areas. And fiber can be stitched, appliqued, woven, wrapped, knotted, or crocheted to provide an exciting wall environment. Wood can be carved from one piece to express a complete idea, or many scraps can be assembled to be grouped within box-like structures placed next to or on top of each other. Modern technology has given us many alternatives, including those materials mentioned here. They can be used alone or combined with others to create a powerful statement and provide a potpourri of visual stimulation.

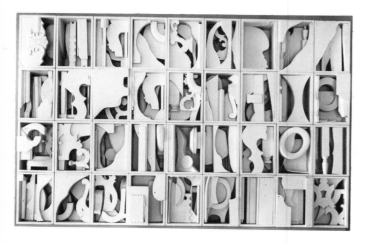

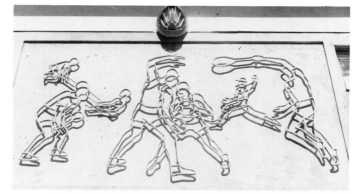

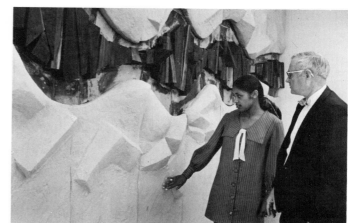

(Above)
Scraps of wood, some found and others formed to fit the space, are arranged in a grouping of box structures to create a wall sculpture entitled New Continent by Louise Nevelson. Courtesy of the St. Louis Art Museum, Forest Park, St. Louis, Missouri

(Top, right)
Heavy aluminum was used in this outline relief, Playground Activities, by Edward T. Hoffman III, above the entrance to a playground building in Philadelphia. Courtesy of the City of Philadelphia, Pennsylvania. Playground at Tomlinson Road and Gifford Avenue

(Bottom, right)
The versatility of materials is demonstrated in this combination of copper and black walnut set in sand-plaster panels by Melvin Schuler. Courtesy of the Pacific Gas and Electric Company, Humboldt Division office building, Eureka, California

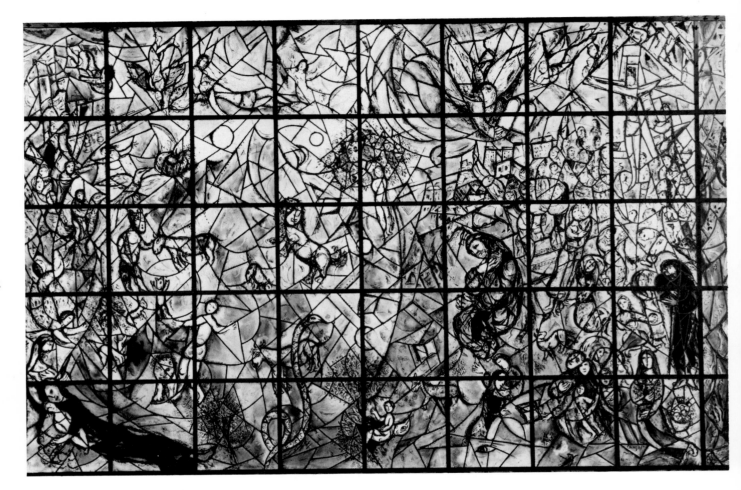

A stained-glass panel by Marc Chagall becomes a beautiful mural. Depicting the themes of "Peace and Man," it is a memorial to former Secretary-General Dag Hammarskjöld in the lobby of the United Nations Secretariat Building in New York City. Courtesy of the United Nations/Nagata, New York

Chapter Three

Some Design and Resource Help

Any mural idea, no matter how clever or intellectually exciting, will lose its vitality unless it is organized visually in an aesthetically pleasing manner. This can be accomplished by carefully arranging the elements of art (line, form, color, space, texture, value) according to the principles of art (dominance and subordination, balance, variety, unity, proportion, rhythm, and movement).

Using the Elements and Principles of Design

Were a class of students to decide to produce a transportation mural, one could begin by determining whether the early sketches show too much activity with too many vehicles of equal size. Could some be eliminated? Could others be made larger or smaller? These questions lead the way to a lesson on the development of a focal point, or the principle of dominance and subordination. This principle can be achieved through prominent use or contrasts of color, shape, size, value, or texture.

Most visual art forms require an area of major emphasis to sustain the attention of the viewer, a spot that attracts the eye and provides enough interest for the viewer to pause momentarily before moving on. Without this focal point (and related portions that are successfully subordinated to it), a work may have the quality of an all-over pattern similar to wallpaper. The same concept applies to other disciplines. Musical compositions have a main theme or melody, literature is written about a dominant individual or subject, and dances are choreographed to develop a central idea.

There are many ways to establish dominance in a mural, and the students will easily recognize dominant themes when placed in the context of their own lives. "How do you attract attention to yourself if you are in a group? What makes a certain individual stand out from the rest? How can this concept be shown in art?" Through noticeable differences in relationships of size, color, value, intensity, or texture of an area compared with surrounding areas and the rest of the picture, contrast can be provided. A figure that is larger than the others attracts a viewer's interest, as does an area of warm color against a cool background, a light form among dark forms, brilliant tones juxtaposed against pastels, or interesting surface textures placed beside spaces of emptiness. The careful grouping of objects, convergence of lines, or directions of movement, and any other type of obvious activity, also direct the eye to it.

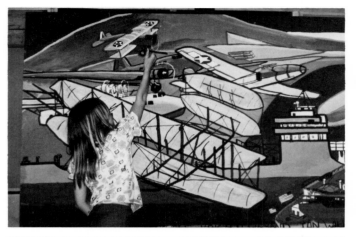

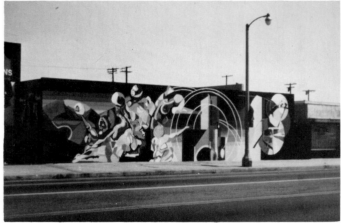

(Top)
Variety of size adds interest to this mural depicting the history of air transportation. Courtesy of Bakersfield City School District

(Bottom)
Curving lines and strong contrasts of light and dark provide a focal point in this street mural painted by high-school students. Courtesy of San Fernando Gardens, California

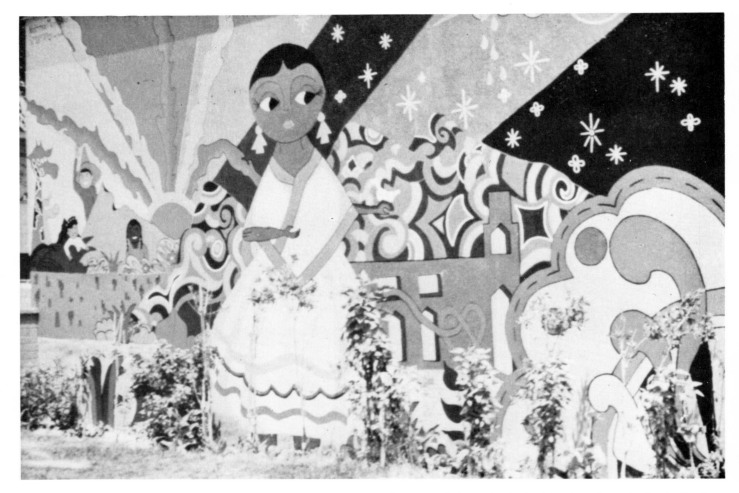

After selecting the most important part or portions, then redeveloping and replacing them on the mural's design so that an adequate focal point is provided, the students should study the result for overall balance. Is there too much activity on the right or left side of the design? Are there too many shapes and lines on the bottom, and not enough on the top? It is not necessary to fill every space, since voids are as desirable in art as rests or pauses are in music or speech. But a visual type of equilibrium is vital and frequently can be achieved by rearranging rather than adding new forms.

Balance is a universal law of nature. Night balances day, summer balances winter, rest balances activity. Our lives depend on this law. It is involved in everything we do. In art, balance is achieved in different forms: formal, or symmetrical; informal, or asymmetrical (less obvious than the first type); and radial.

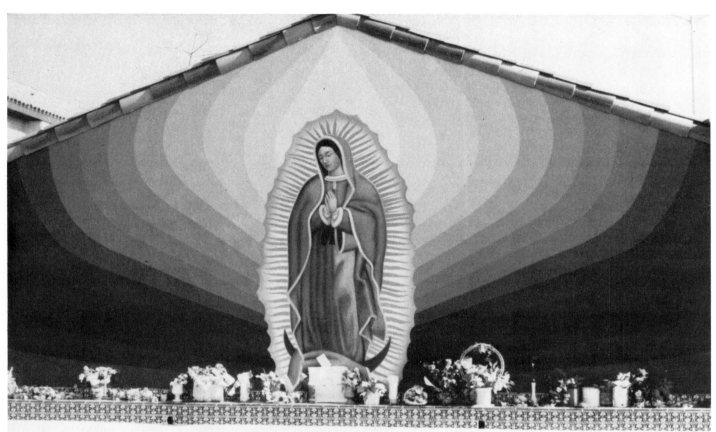

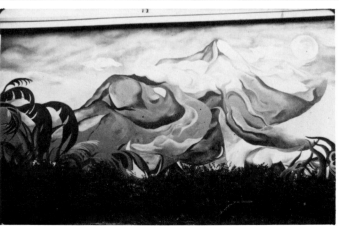

(Above)
Marazilla mural, a neighborhood shrine, illustrates symmetrical balance in the background of the central figure. It was painted by neighborhood gang members under the direction of David Lopez at the headquarters of the Housing Authority of the County of Los Angeles.

(Left)
Visual equilibrium in which unequal forms tend to balance each other without a feeling of too much weight on either side; an example of asymmetrical balance. Courtesy of the Estrada Court Housing Development, East Los Angeles

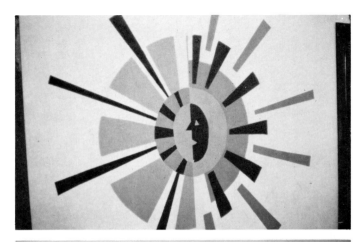

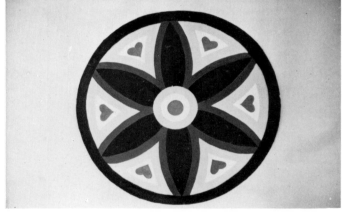

(Top)
Radial design with a variety of line thicknesses and shapes to compel the viewer's interest. Mural by high-school students of Los Angeles Unified School District

(Bottom)
A typical Pennsylvania Dutch hex sign or barn wheel made with a six-pointed star within a circle.

Any art form having symmetrical balance shows identical images on either side of an invisible line. This concept can be explained to a class by having the students visualize a teeter-totter with a pair of twins wearing identical clothes of bright red, sitting on opposite ends of the board. If we draw an imaginary vertical line through the middle where the board touches the central support, both sides will be the same, balancing each other perfectly in form, color, and value. One side will be the reverse of the other.

Imagine that one of the twins, though of the same size and shape as the other, is wearing dull gray instead of red. Which one would attract our immediate attention? If we were painting a picture of this scene, what would we do to the gray suit to give it more prominence? Of the several ways to solve this problem, one is to add texture or pattern to the gray clothing. Another method might be to dull the red outfit worn by the other twin. How else might balance be achieved? Now suppose that after playing for a period of time one of the twins wants to go home, leaving his brother to find a friend who will teeter-totter with him. But the friend proves to be much heavier than the little twin. How can the two determine a way to balance the teeter-totter? The heavier child obviously will have to move closer to the center of the board, unless a very light third child could be found to sit on the twin's end of the teeter-totter.

In a similar way, the organization of many art problems can be solved. Adjustments must continue until a feeling of visual balance has been achieved. This is called asymmetrical balance, in which opposite sides of a picture do not appear the same in a mirror-image sense; rather, because forms, colors, or textures are carefully placed in space, a feeling of balance is evoked in the viewer.

Radial balance is not used frequently in murals. It is a type of symmetry in which members of a structure radiate from a central point, as do the spokes of a wheel from a hub, or the petals of a flower from the center. Compositions formed in this fashion have a tendency to be somewhat formal and mathematical. Examples of radial balance are found in the large barn wheels (often called hex signs) of the Pennsylvania Dutch, in thirteenth-century rose windows of Gothic cathedrals, in kaleidoscope designs, and in some examples of Op (optical) art.

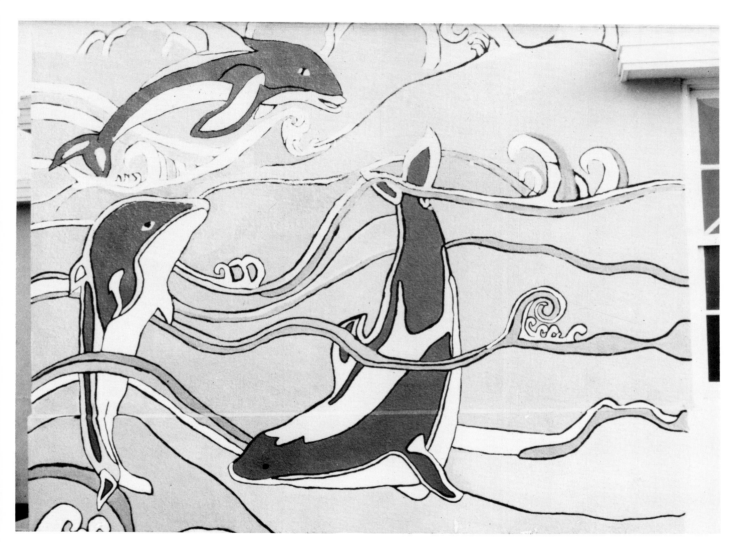

Variety of form and values are evident in this school mural. Courtesy of Santa Monica Unified School District

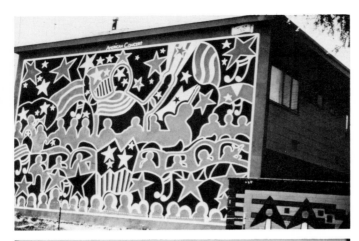

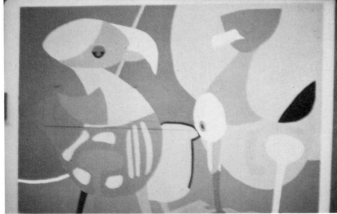

(Top)
American Concert, *a painting on the end wall of a building in a housing development, displays unity in spite of the visual activity and variety of forms. Courtesy of the Estrada Court Housing Development, East Los Angeles*

(Bottom)
The space flowing around these shapes is as interesting as the forms themselves in this student mural. Courtesy of Los Angeles Unified School District

Because evaluation is an important part in the creation of a work of art, the mural should be studied frequently during its creation. Is there enough variety in it? Too little can make it monotonous, and too much can be overpowering. But variety is necessary to provide interest. Transitional areas also should be considered. They help to soften abrupt changes of form or direction, thus imparting a feeling of unity and harmony. Does the entire work hold together harmoniously? Perhaps more adjustments will need to be made after each question is asked during the on-going evaluation process.

Checking the proportion of the shapes or silhouettes formed by the various groupings is necessary to the success of the mural as well. Objects should be considered in relation to each other as well as to the surrounding space. Many students overlook the fact that background spaces, or portions behind areas of activity, can be as important as the central figures. Shapes are not plunked down in a void. As houses, trees, animals, or people are placed on a piece of paper, their positioning causes the negative space flowing around them to have form also. Wise use of this space can enhance a work of art just as improper use can detract from it. The proportion of forms to their surrounding spaces is vital to the complete design.

It is natural to repeat lines, colors, and shapes. Doing so creates a sense of rhythm and is very satisfying. We breathe and walk in rhythm, our hearts beat in rhythm, and our daily schedules usually repeat themselves in cycles. It is another law of nature the artist cannot ignore. If an interesting line or shape appears in the mural, the students could be asked if one similar to it might be placed nearby. Possibly it might be repeated several times. Movement can be established in this manner, urging the eyes to travel over definite paths, following the elements of art quickly or slowly.

If students use the principles of art as a checklist in evaluating their efforts, they will know why their work is valid. They will be able to develop a composition with good organizational concepts while translating their ideas and feelings into a meaningful mural. The principles of art are universal truths, linked to the laws of nature.

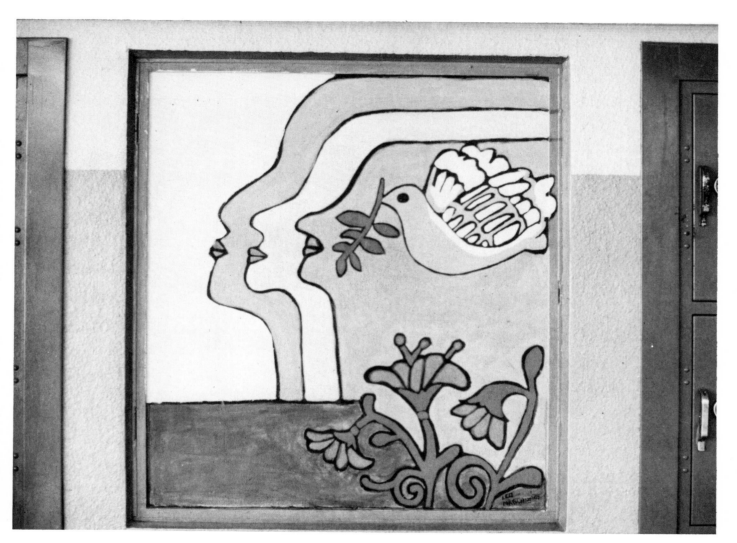

A pleasant, rhythmic feeling results from the repetition of form in a mural painted by junior high-school students. Courtesy of Santa Monica Unified School District

Looking at Art

Although the principles of art provide a valuable measurement scale for students creating an art form, they are not enough. Young artists should see what professional artists have made and how they have solved the problems of organization and mood in making visual statements. If good, original works of art are not available, large reproductions should be substituted for study. Time should be alloted for students to look at them, to search and to respond to the mood, subject, organization, and techniques used. Teachers could guide this study by asking a variety of appropriate questions, such as: "Is the picture strong or weak, busy or lazy, bright or dull? Are the colors warm or cool? How are the principles of art applied? Is the mood cheerful or sad, spooky or tranquil? Is the character of the work brave or cowardly? How did the artist use the materials?" Responses to these questions will give students an opportunity to verbalize their own feelings and to compare their experiences with others. Also, communication between pupils and the teacher is facilitated.

A study of the works of master artists need not be done with an intent to copy, because students should be encouraged to be original. But if the questioning approach is used, the students will have an opportunity to appreciate the problems encountered during the creative act by all artists. They will be able to learn to evaluate critically while developing their perceptual awareness. This approach ideally will give them enough background to develop a strong sensitivity to their own environment with the knowledge needed to help improve it.

The Professional Artist

A professional artist works in a manner similar to that of students, but there are pronounced differences. The artist may be asked to create a specific mural theme for a specific location. For example, suppose an artist has been commissioned to illustrate an event of local history to be placed on a large wall of a public building. The first step is to decide on the materials to be used. Is the mural to be painted, made of glass mosaic, ceramic tile, metal, wood, or plastic? Sometimes this is predetermined for the artist by the officials in charge, but frequently the choice is left to the former. Then the artist must do extensive research on the event or subject to be portrayed,

select the most important aspects, and make a sketch in proper scale, usually in color, to be submitted for approval. The artist may be asked to make changes, to include certain images, or to delete others. Or he or she may be requested to develop a completely new mural design. After approval of the sketch has been given, the artist must prepare the wall surface before working on it. Under some circumstances, the task might be too great for one person, so one or two assistants could be employed. During the entire process, the mural should be evaluated by the artist in charge in much the same way students in schools would evaluate their work.

Sometimes artists who are asked to make a mural are allowed to choose their own subject matter. Under these conditions, a prime consideration would be to create something suitable for the particular site. Other times artists may find blank walls, seek out the owners or local authorities, and ask permission to decorate them with original ideas of their own. Occasionally, competitions are held for which artists may submit designs to be used in providing murals for specific areas. These may be either on a local or national scale. There are other approaches, too, such as groups of creative people working together to enhance a neighborhood with murals.

The procedures suggested here for creating murals are valid for almost any level of professionalism, age, or experience. Primary teachers would simplify them, and secondary teachers augment them. Similarly, professional artists would streamline their approaches to meet their more sophisticated requirements. The basic methods, however, will remain much the same, varying only in intensity and degree.

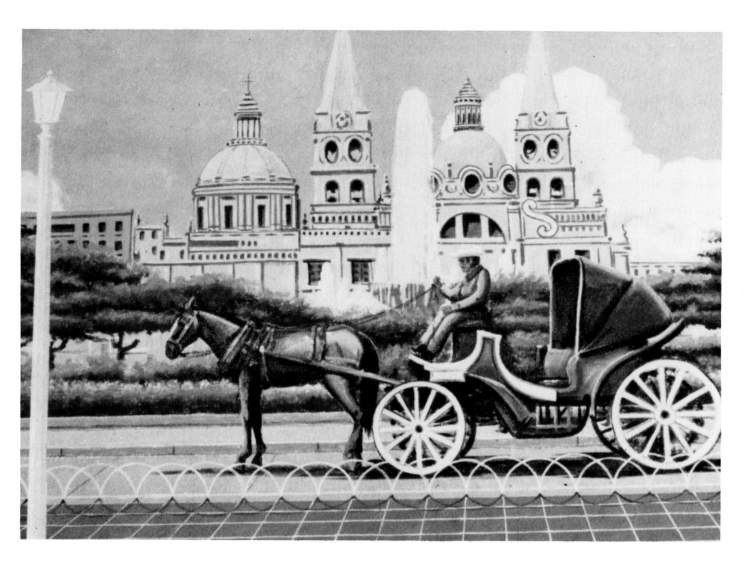

A Chicano artist painted a colorful historical mural for a Los Angeles city street.

(Left)
Dr. Stanislaus Wisniewski painted an abstract mural on the walls of a narrow stairwell at Columbia University, New York City.

(Right)
This abstract mural of flat color and clean lines was commissioned to blend into the decor of the building. Courtesy of Kern Schools Federal Credit Union, Bakersfield

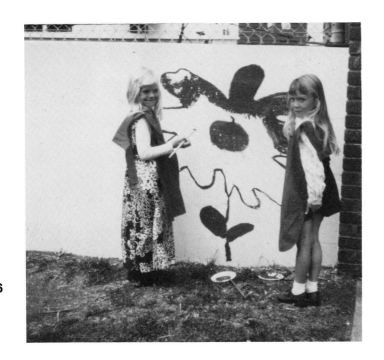

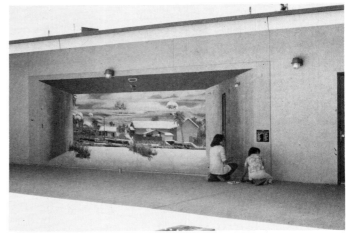

36

(Above)
Primary-school children are developing a simple, yet colorful, mural
for their school. Courtesy of Solano Beach Unified School District

(Right)
A sophisticated "fool-the-eye" mural by junior high-school students
leads the viewer into believing a corridor goes through the solid wall
into the area beyond. Courtesy of Bakersfield City School District

Chapter Four

Getting Started

Everyone responds to his environment. Sensitive individuals will react more readily, perhaps, than those who are less aware of their surroundings, but all people are affected to some degree by everything that encompasses them. Visual artists, or those in related fields, have the ability to produce works that cause strong responses. Murals are among these works, helping to change the environment. They provide a powerful means of communicating an idea producing a reaction in interested viewers.

Developing Mural Ideas

Organization of thought is essential in developing a mural. As with all of the arts, it is necessary to be selective. A poem is not formed by listing words found at random in the dictionary, music is not created by sitting on the keys of the piano, and a mural is not composed by freely sprinkling a surface with unrelated visual ideas. A theme and careful planning are necessary to achieve success.

The approach used in getting started depends on the age level and abilities of the students. If they are young elementary-school children, a more thorough type of motivation would be advisable than that given to high-school students, since the former's life experiences are more limited than those of the older group. But a topic must be chosen that is of sufficient value to sustain the interest of the young artists who will create the mural. How is this topic chosen? Who decides what it should be?

There are times when basic interests or the study of certain subject matter are so important that they lead naturally into other areas of expression, such as the visual arts. A teacher should capitalize on these situations by asking the class if a mural would be a possible way to make a statement concerning these situations. If so, where should it be placed? Depending on the site, what materials should be used? The site also might suggest specific ideas, such as a sports theme for a school activities center. But general themes can be appropriate for many areas. An historical design could be painted on the walls surrounding a public park, or an abstract floral composition might be placed on the interior walls of a school library. These decisions must be made before the project begins.

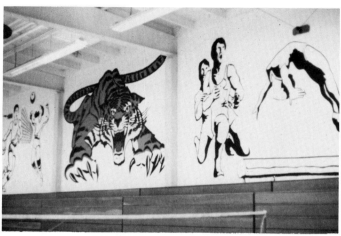

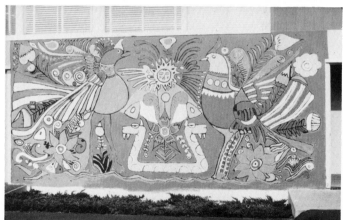

(Top)
The belief in the strength and ferocity of the Morse High School athletic teams is communicated through the tiger mascot mural in the gymnasium. *Courtesy of San Diego Unified School District*

(Bottom)
A well organized mural enhances the exterior of this high-school building. *Courtesy of Santa Monica Unified School District*

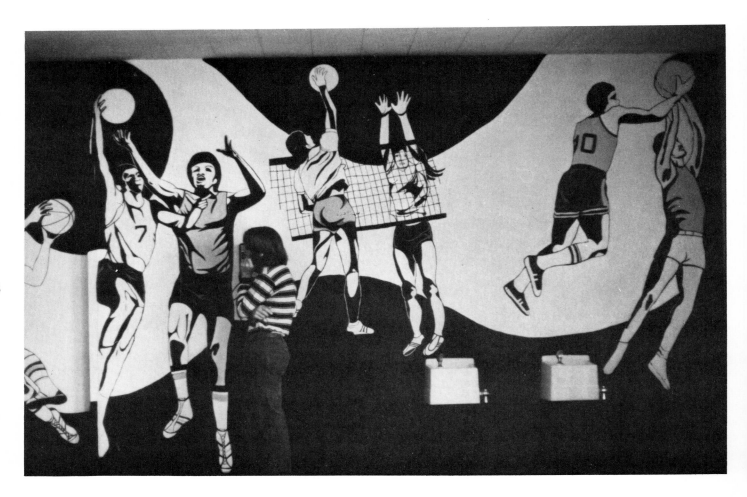

An energetic sports theme enlivens a high-school wall. Courtesy of
Brea-Olinda Unified School District, California

What if a mural has been planned but a suitable topic cannot be found? Rather than impose one on the students, the teacher could question them about experiences and interests concerning their own lives, school activities, and community concerns. A surprising number of ideas will surface with one student's answer, stimulating the thinking of a classmate whose reply, by association, will spark someone else with a new thought. And the chain of ideas will grow. A useful method is to jot down these links on a chalk board or a large piece of paper in full view of the class as the suggestions are made. This process will give the pupils an opportunity to reflect on the suggested topics.

On occasion, a student might mention a popular cartoon character as a theme for a mural. However, the act of creating something from one's own thoughts or imagination should be given more importance than copying or borrowing what already has been done—and, in many cases, is copyrighted. The amount of time spent on a mural is justified only by original work. A teacher, in the role of leader and mediator, can encourage the students in this direction, stressing the need for using their own ideas in art experiences.

When suggestions for mural topics no longer seem to come easily, the students should check the list to see if some subject matter is more popular than others. Class discussion of pros and cons, suitability, practicality, and general interest can help the undecided. The final choice may be determined by voting.

Beginning the Mural

After a topic is determined, a decision must be made concerning ways to begin the mural. If the children are in the primary or intermediate grades, a simple method is to place a long piece of project paper on a wall and ask the children to plan how they could decorate it. They may create specific subjects related to the theme of the mural, such as tropical fish, trains, or costumes. When finished, the subjects of the mural can be cut or torn, then pinned or taped wherever the students might choose on the paper background. Materials and techniques could involve colored paper, charcoal, colored chalk, crayon, paint, pencil, or fiber-tipped pens. Although this might seem to be a chaotic method, it provides an opportunity for considerable learning to take place. The total effect must be viewed

Individually cut-out, crayoned figures were placed on this mural by primary children during a study of colonial life. Courtesy of Mrs. Arnold Fauskin, Kern County Public Schools, California

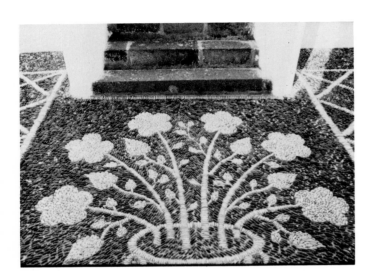

and discussed: Is it organized or a jumble of unrelated shapes? A comparison might be drawn between the careful planning of a pebble mosaic in relation to the random dumping of gravel on a path. A work of art does not happen accidentally; it must be planned.

How can the students discover a better way to make their mural? Can they rearrange the pieces to make sense and also to be visually pleasing? Is it possible to be more selective in deciding on which parts to use?

As the students work with the teacher, they might decide to paste the original pin-up figures on the final mural surface. Although it is possible to place them on plain, unadorned paper, a background that has been painted, crayoned, chalked, or covered with cut or torn paper shapes will often enhance the total effect. Or the students could trace their original drawings onto another type of material to be cut out and placed directly on the mural. Also, they might transfer their designs to a different mural surface to be filled in with a variety of media. Perhaps they may completely redesign their first pictures. Regardless of the direction selected, the entire class can be involved in arranging the separate shapes on the mural background.

Another procedure is for each class member to draw an individual miniature of the complete mural as he or she envisions it. The most suitable one may be chosen by popular vote, a committee, or the teacher. It is possible that portions of several of the various drawings could be selected for use in the final mural. These ideas can be combined into another miniature of the mural sketched by a single student or several working together. The originator, or originators of the small pictures then have the responsibility of transferring the design to the large mural area. The actual execution of the mural can be completed by committees. But any individual expressing a desire to participate should be allowed to do so.

A third method depends on the work of small groups, although the topic might have been chosen by the entire class. Committees can provide the necessary researching of the subject matter, take charge of materials, and block in the basic designs. Another group, or possibly all interested students, will then complete the mural, using the medium chosen.

(Above)
A carefully designed pebble mosaic in the courtyard of a home in Santorini, Italy. Photograph by Paul Wiseman

(Opposite)
Junior high-school students have transferred their designs to a plywood mural surface for painting. Courtesy of Bakersfield City School District

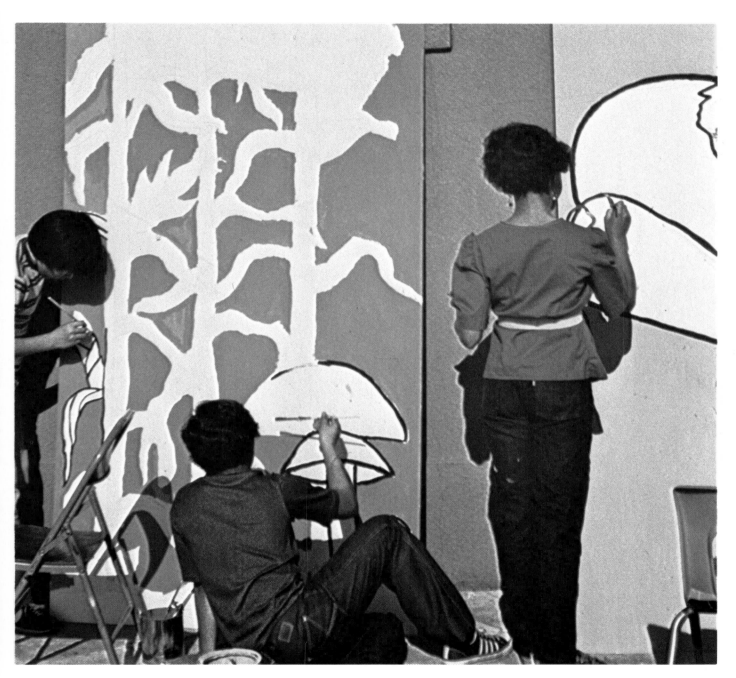

Committees can also be organized in other ways. One section of students can put in the background, another the buildings, and a third the details of people, animals, or plants and trees. On murals with more complex designs in which the backgrounds cannot be separated readily from other forms, group members can work on specific sections. At other times, close teamwork causes spontaneous responses, with some students deciding to work in several areas.

A fourth procedure involves the entire student body in a general school project. Each child can be asked to create a small two- or three-dimensional design to be arranged on and adhered to a large surface to complete a composite mural. These individuals' designs can be made of paper, cardboard, baker's dough, or ceramic tile or can be crayoned, painted, printed, or collaged. Coordination of the project should be handled by a teacher who would work with other staff members or student committees. The value of such an undertaking lies in the fact that every child has an opportunity to contribute to a permanent, attractive display for the school.

One of a group of student paintings being considered in a search for a mural design. Courtesy of Brea-Olinda Unified School District

Occasionally, students will identify a place that would, in their opinion, be appropriate for a mural. They might volunteer to create one, and should be encouraged and asked to submit sketches of their ideas. If approval is given, they can then proceed with the actual task of mural making, being responsible to a teacher for their work.

At times, a single student will want to tackle a mural alone. Such individuality is commendable. A teacher should work with this student as an advisor from the presentation of the first sketch to the completion of the project.

Although expediency may be tempting to a teacher, it is wise to remember that his or her role is that of leadership. Student art is at its best when it remains student art, unless it definitely is understood that the project is to be a joint adult-student undertaking.

Subject organization is as important as design organization, in which the principles of art serve as guidelines. Careful planning is required to bring about a melding of the two. But in addition, a third and frequently overlooked factor is needed: the mood of the mural. It may be subtle and quiet, causing feelings of inner peace for the viewer. Or it may burst forth with a powerful impact, providing strong reactions of joy or horror. This mood or feeling is the plus factor that can boost a mural a step higher, making it worthy of art and the environment.

Individual block designs created by high-school students are combined to make a free-standing mural. Courtesy of Brea-Olinda Unified School District

44

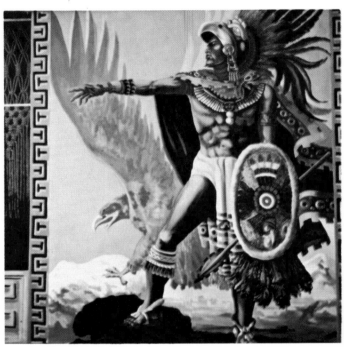

(Left)
*Junior high-school students chose a good spot for this mural above
a recessed trash container in a hallway. Courtesy of Santa Monica
Unified School District*

(Above)
*The strength of an Aztec warrior is emphasized by strong value
contrast and the carefully placed shapes. Courtesy of Los Angeles
Unified School District*

Chapter Five

Making the Mural

After a theme or idea for a mural is chosen, the artist should determine the manner or style that will be used to develop the idea into a final product. The artist's choice of style will depend upon his or her ability, the effect he or she wants the mural to have on others, and the relationship it will have to the immediate environment. Materials must be selected to emphasize that style. Paints, for instance, are versatile. They can be used equally well to create soft and freely flowing areas of color or hard-edged abstractions. Less adaptable materials, for example, metals, can sometimes confine an artist to a somewhat rigid style.

The Large Picture

If students wish to depict a definite event that occurred at a certain time and place, they could make one large picture for a mural. It could be similar to a giant photograph of the occasion exactly as it might have appeared to observers at the moment it happened. A representation of the whole class on the first day of school with a self-portrait painted by each student is an example. Or the class could decide to portray an historical episode using the theme of man's first moon landing or the flight of the Wright brothers at Kitty Hawk. But a judgment will have to be made concerning the degree of realism required to do this. Should the mural be similar to a huge photograph? Should it be realistic, a slight suggestion of the idea, or completely abstract? How much illusion of depth will be needed? Will it be better to overemphasize space by using an extreme perspective, or will unshaded, overlapping shapes of flat color suffice? Will edges be clearly defined, outlined with a contrasting color, or fuzzy? Should color and design be representational and natural, or be exaggerated to create special responses in the viewer? (Vivid reds and oranges, for instance, could be used to produce a feeling of excitement. This could be intensified by the use of exaggerated diagonal lines and angular shapes.) The answers to many of these questions will depend on the age, background knowledge, and technical abilities of the students.

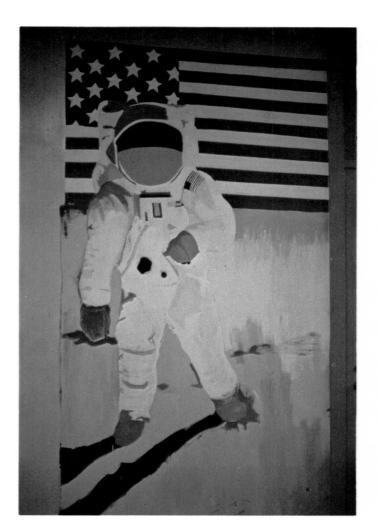

High-school students have chosen the historic moon landing for a mural theme. Courtesy of Brea-Olinda Unified School District

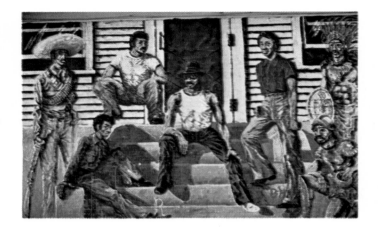

(Left)
This realistic wall painting gives the illusion that the figures on the steps are about to move. Courtesy of the Ramona Gardens Housing Development, Los Angeles

(Above)
Unshaded, overlapping areas announce the art gallery in a high-school corridor. Courtesy of Brea-Olinda Unified School District

A Series

Another mural style is the use of a series of pictorial ideas. Again, these may be realistic, partially representational, or symbolically abstract. A series can be developed in several ways. One approach is to use a single theme showing related activities that are taking place simultaneously or nearly so. The processes involved in putting out a newspaper can be an example. Everything that transpires from the time the reporters gather the material and write it, to its run through the presses and delivery as a finished product to newstands or homes, provides enough material to create an interesting mural. A circus is another topic in which several events occurring at the same time in different locations might be covered in a series statement. Student artists can capture in art form their ideas of the colorful performances in the main ring, the unusual side shows, appealing animals, or funny clowns. Depending on their interpretation, a quality of excitement and activity typical of a circus can be generated.

A different type of series illustrates events stretching over time and space. This style is advantageous, because a great deal of material may be covered in a limited area. By carefully choosing characteristic examples and placing them sequentially, it is possible to depict historical themes, such as the growth of a city, the evolution of inventions, or variations in different costumes over several centuries.

Whether artists select a single theme for a series or a sequential evolution of an idea that takes place over a period of time, there are several ways artists may interpret them. One of these could be the rendering of separate symbols or pictures. They can be arranged against a general background that sets the stage, or they can be confined within blocks of varying form, possibly of different colors. Outlines of black or those of different hues could be used around these shapes if desired. Or the boundaries may be determined by the use of decorative devices relating to the overall idea. An advantage of this type

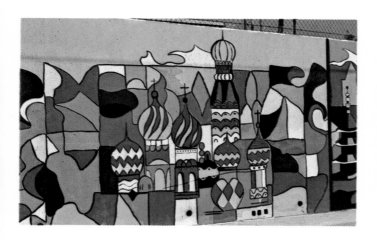

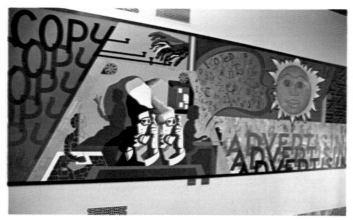

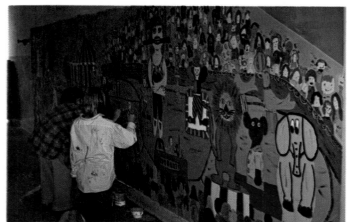

(Top, left)
An exciting interplay of color and shape depart from reality to add interest to the retaining wall of a school yard. Courtesy of Sierra Park School, Los Angeles Unified School District

(Top, right)
The related activities involved in the making of a newspaper are designed into a single mural by Clayton Rippey. Mural in the Bakersfield Californian newspaper building, Bakersfield, California. Courtesy of the Cézanne Gallery. Photograph by Jack Knight

(Above)
Sixth-grade students are working on a circus-theme mural for the main corridor of their school. Courtesy of Bakersfield City School District

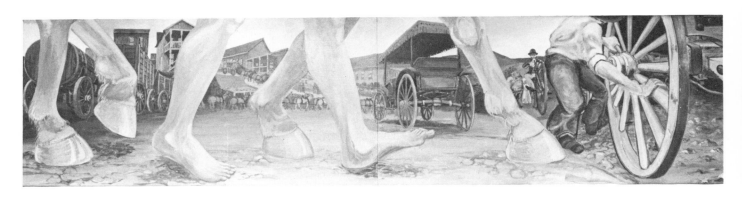

A pictorial history of transportation depicts important mile posts in sequential order on this eighty-foot mural designed and painted by Bruce Hebron, Robert Rhoades, and Nancy Dunn. Courtesy of the California Department of Motor Vehicles, Bakersfield

of mural is its simplicity of execution, making it possible for one or two students to work together on each block. Although it can provide a very successful statement, it can tend to be slightly stiff and spotty unless carefully handled.

A series also can be developed by interweaving ideas by blending or overlapping them so that they merge one into the other. The arrangement may be horizontal, vertical, spiral, or a variety of patterns. Rhythmic movement can be established through any of these styles, inviting the viewer's eye to move through a succession of visual ideas. Dominance should evolve rather easily as some areas are accented. Others may blend together as a group of softened vignettes.

(Top)
A contrasting outline emphasizes the figures in a sports mural. Courtesy of the Fresno State University Audio-Visual Department, Fresno, California

(Bottom)
Painted cardboard rectangles have been grouped successfully to create a large mural panel for a school library. Courtesy of Los Angeles Unified School District

(Opposite)
Movement and dominance are achieved through careful arrangement and blending of forms in this 30' X 36' mural, Les Sources de la Musique *by Marc Chagall for the lobby of the Lincoln Center Metropolitan Opera House in New York City. Courtesy of Lincoln Center for the Performing Arts, Inc. Photograph by Loui Mélancon*

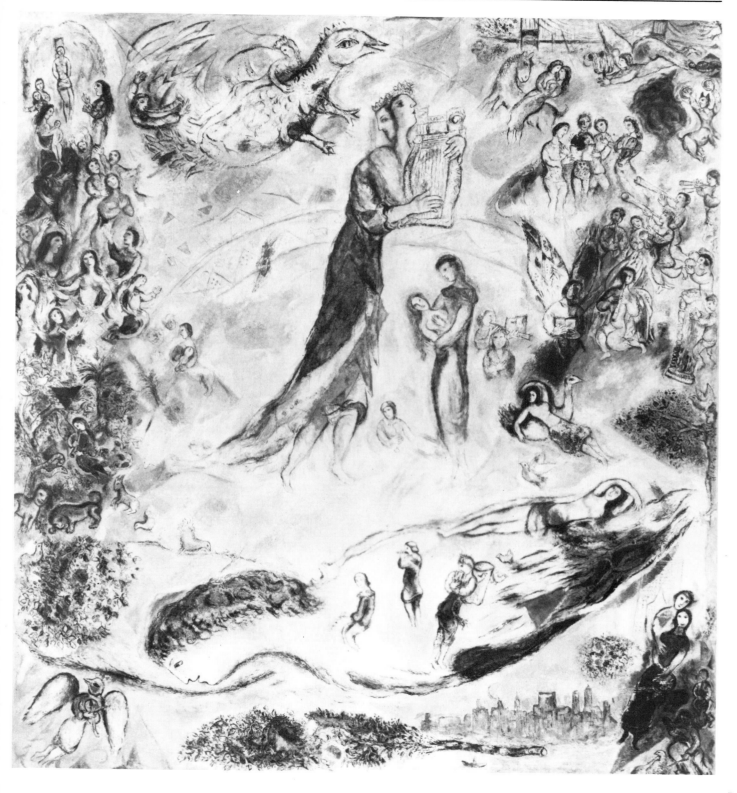

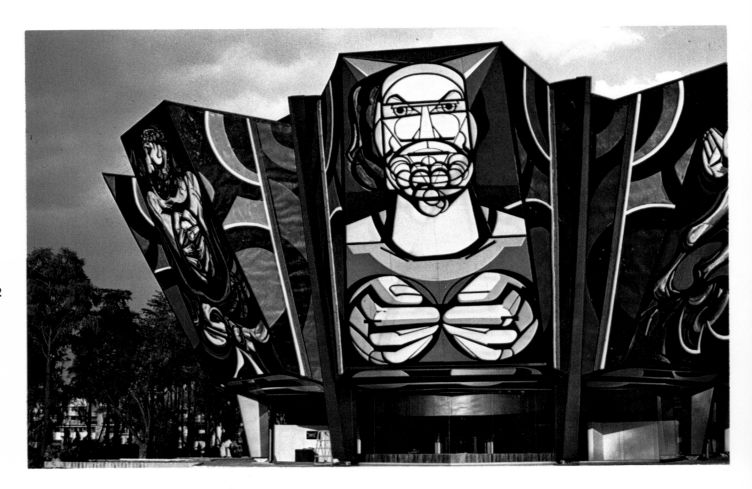

Siqueiros, the Mexican artist, used three dimensions in this striking Polyforum mural in Mexico City. Courtesy of David Alfaro Siqueiros, Mexico City

Variations

There are as many ways to develop murals as there are ideas or topics. A simple variation is the placement of one or two large transparent, symbolic forms over a more detailed portion of the picture. In showing the development of agriculture, for instance, small farm workers, plowed fields, and barns might be viewed through the superimposed shape of a large translucent tractor symbolizing people's dependence on the machine. Such overlays not only help to expand an idea, but are also valuable in developing a unity to the entire mural.

Another possibility is the use of an occasional three-dimensional form to emphasize certain aspects of the mural. Papier-mâché made of newspaper strips or patches bonded together with wheat paste or a similar substance is a good way to build up portions of a mural that will benefit from a sculptural effect to accent special interest areas. David Alfaro Siqueiros used a similar technique in his huge *March of the Humanities* mural in Mexico City.

Photomontage is an effective technique to use in creating murals. Letters, numerals, and pictures, cut from magazines or any printed material, can be used separately or combined with paint, ink, fabric, and other substances to make a unique wall design. The manner in which they are put together can be both creative and interesting.

(Left)
Three-dimensional form is created in a mural sketch using magazine collage, papier-mâché, and ink by a junior high-school student. Courtesy of Bakersfield City School District

(Right)
This photomontage, People of Upper Peninsula, *is handsome as well as meaningful, by Homer Mitchell for a wall of a Michigan savings and loan building. Courtesy of Detroit Northern Savings and Loan, Hancock, Michigan. Photograph by Bathazar Korab, Troy, Michigan*

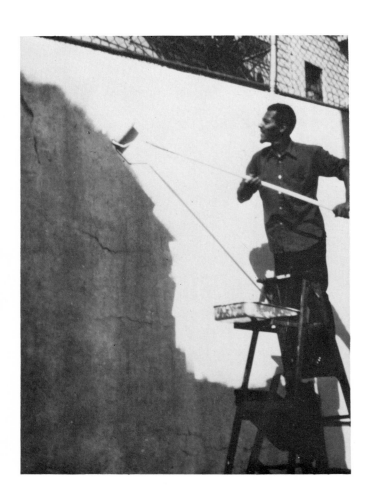

A primer coat is applied with a roller to an old wall. Attaching an extension to a handle makes it easier to paint the hard-to-reach areas. Courtesy of San Francisco Unified School District

Preparing the Surface

If the mural is to be painted on a new wooden surface such as plywood, a primer coat must be applied before the design is drawn. Walls that previously have been painted need no prime coat unless they are in poor condition. However, they must be cleaned thoroughly by washing away the accumulation of dirt and grime, even though they appear to be spotless. Paint that is glossy should be rubbed well with steel wool or sandpaper, then wiped with a lint-free cloth before applying a fresh coat of paint. A word of caution: An oil- or alkyd-base primer must not be used on masonry walls. If moisture is present at any time, especially in exterior walls, the oil- or alkyd-base primer may break down as a result of the alkaline elements in the wall.

A wall that is to hold a mosaic must be scrubbed and waterproofed, particularly if the area is made of wood and will be exposed to the weather. One should check with local building supply companies for advice about products to use for the preparation of specific surfaces before embarking on a major project.

Transferring the Design

A simple method of design transfer was suggested in Chapter 4, in which the students cut shapes from their large, full-sized sketches and fastened them permanently to the mural. These forms can also be used as templates around which to trace. However, this is often not feasible, since most murals have their beginnings in small drawings. Small drawings eventually should be made to scale. If the finished product is planned to be the size of a standard four-by-eight-foot sheet of plywood, the guiding sketch could be quite workable if it were sixteen-by-thirty-two inches, a scale of four inches to the foot. If more convenient, a scale of two inches to the foot may be used, resulting in an eight-by-sixteen-inch sketch. However, it may not be large enough to include adequate detail.

Regardless of the scale size, a grid should be made to divide the small sketch into squares that will correspond to the one-foot squares on the full-sized drawing or cartoon to be developed. Graph paper also can be used to eliminate the need for drawing lines to prepare a grid. All lines going in one direction should be numbered and those that cross them going in the opposite direction should be lettered. This method will help

to simplify the process and will guide the artist in determining where the design appearing within each square of the small sketch should be placed in enlarged form on its matching square of the larger drawing. This eventually will become a full-scale replica of the finished mural. Having a paper replica provides opportunities for making major changes before work on the final surface begins.

When all adjustments have been made, the cartoon can be traced on the wall or mural panel by using carbon paper or the pounce method, or by covering the back of the cartoon with graphite pencil and tracing over it. In the pounce method, a hand-held tracing wheel with sharp points is rolled over the lines of the cartoon, making small holes in the paper. The cartoon is then placed on the mural surface, and a powdery substance, usually charcoal dust, is placed in a small cloth bag and forced through the holes in the cartoon. This is done by lightly pouncing the bag over the holes in the outline of the drawing, reproducing it on the surface beneath. Sometimes this middle step, or cartoon process, is eliminated and the grid is formed directly on the area selected for the mural.

A faster and more accurate way to place a small sketch on a large area is to use an opaque projector. As the original design is projected on the wall, outlines can be traced and made ready for processing with paint or other media. An advantage of this method is that as the machine is moved farther from or closer to the wall, the image enlarges or diminishes. Students can jockey the projector back and forth to find the best size for the individual portions, changing dimensions until the last minute, as continual evaluations determine needs. An overhead projector can be used in a similar way, but an in-between step is necessary before projection. The original sketch must be placed under transparent film and then traced on the film with a marking pen. Then the film can be flashed on the wall, which has been made ready for the same processes used with the opaque projector. Regardless of the method chosen to place the design on the wall, the important point to remember is that the small drawing should be accurate enough to be a valid reference and guide for the artists.

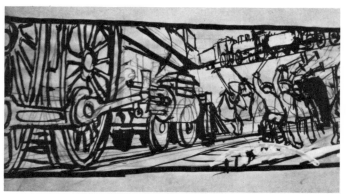

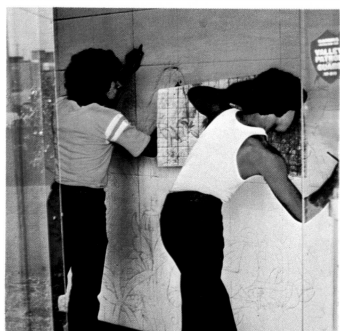

(Top)
Full-size cartoon ready for transfer to mural surface. Courtesy of the Department of Motor Vehicles, Bakersfield, California

(Bottom)
High-school students transferring a small drawing to a wall using the grid system. Courtesy of San Fernando High School, San Fernando, California

The original sketch for this mural was traced onto transparent film and projected on the wall by an overhead projector. Courtesy of Horizon High School, Bakersfield

At times some people may prefer to sketch freely on the mural wall, adapting ideas from smaller drawings and changing or rearranging areas as the design develops. One of the positive aspects of this method is the extra freedom possible when working directly on a large surface without being confined by a grid or blown-up drawings. Whether the students use a transfer process involving a grid, project the original image on the mural surface, or draw directly on it by referring to guiding sketches, good planning is essential to the development of a quality mural.

Additional Equipment

It does not matter if artists work directly on a wall or on a large sheet of wood or other material that is to be fastened to it, but certain equipment is necessary. If a temporary mural of paper is planned, it can be taped to a wall or placed on low tables while it is being worked on. If moveable but more rigid material, such as plywood or Masonite, is used, it may be propped up on saw horses or blocks of wood and leaned against a wall to make the mural-making process easier.

Ladders are helpful for working on wall murals that are beyond normal human reach. Their main disadvantage is that they must be moved frequently, requiring much scrambling up and down on the part of the artist. For this reason, scaffolds are recommended. These are temporary wooden or metal frameworks that support workers during the mural process. They must be sturdily constructed to preclude the danger of their collapsing under too much weight should several people be on top. Railings are required to avoid unnecessary accidents. Involved and busy artists often forget that they are working several feet above ground and might be tempted to step backward to get a better view of their work. Commercially made scaffolds with wheels for mobility and brakes to hold them steady are ideal. The market affords a large variety, including motorized scaffolds that raise and lower the student and travel over the ground at the touch of a button.

For the artists concerned, much of the joy of mural making is in the creative process itself. This involves taking an abstract idea and forming it into a tangible, satisfying product. It includes the organization of ideas, the development of a style, the processes of transferring the initial drawings to the surface, and the manipulation of materials to make the mural. The methods mentioned are not the only ones usable for murals, but they represent a foundation of suggestions on which the artists can build.

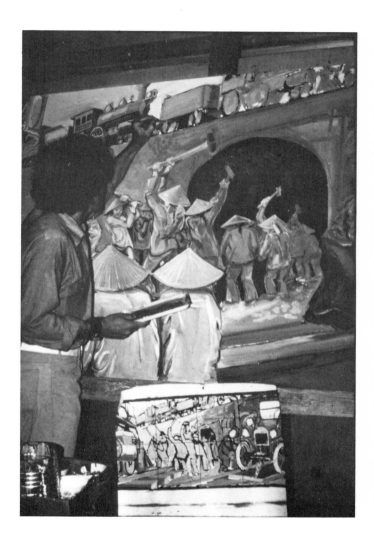

57

The miniature sketch acts as an important reference in painting the mural on its final surface. Courtesy of the Department of Motor Vehicles, Bakersfield, California

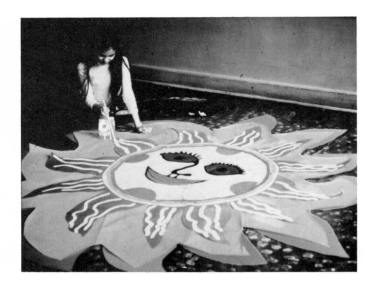

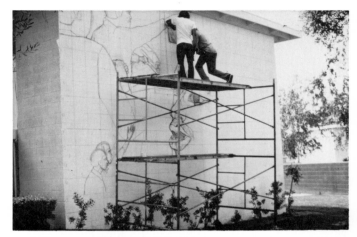

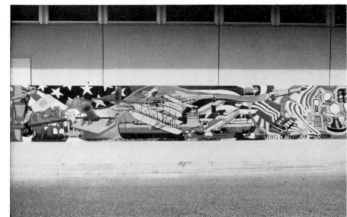

(Above)
In many cases it may be convenient to paint a mural on a surface placed on the floor. When completed, it can be attached to a wall or moved about freely. Courtesy of San Francisco Unified School District

(Top, right)
High-school students work from a scaffolding to draw the mural design on the grid-covered wall. There should be safety railings to protect the students.

(Bottom, right)
American inventions of the past two-hundred years are cleverly woven throughout this 4' X 24' mural painted with acrylic on plywood. The eighth-grade students who painted it displayed thoughtful use of design concepts of form, space, line, color, texture, and value. Courtesy of Bakersfield City School District

Chapter Six

Enhancing the School Environment

The character of school buildings has changed through the years. Two- and three-storied edifices, reminiscent of factories, Tudor-manor houses, Mount Vernon, or movie theaters of the 1920s are fading from view to be replaced by the cluster, module, and finger concepts of contemporary design. These new structural styles have developed as a result of knowledge gained through experience. The demonstrated need for increased safety factors, including ease of exit unencumbered by extraneous obstacles, and the recognition that children require free and individual space have dictated single-floor or simple two-floor structures. However, architectural personality has also been determined by local requirements and the economic ability to afford more than a bare minimum at the time of construction. Some schools are fortunate to have art forms, such as mosaics, sculpture, or stained glass, incorporated into the master plan. Frequently, however, these artistic additions have failed to make it to the drawing board, or, if lucky enough to get that far, have been deleted in the final push toward economic use of the taxpayers' dollars.

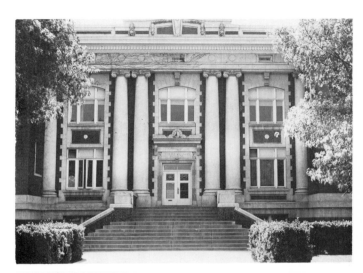

(Top)
The Renaissance style, with its elaborate decorations, was popular for school architecture during the first quarter of the twentieth century. Courtesy of Bakersfield City School District

(Bottom)
A handsome central school building planned with pride. Glass mosaic rectangles add color to the facade. Courtesy of Carthage Central School, Carthage, New York

(Above)
A turn-of-the-century school building is ornamented with turrets, pilasters, Romanesque windows, and an open tower. Courtesy of Bakersfield City School District

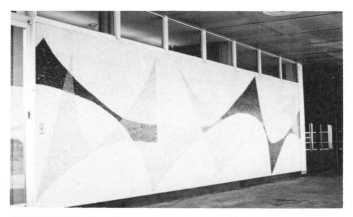

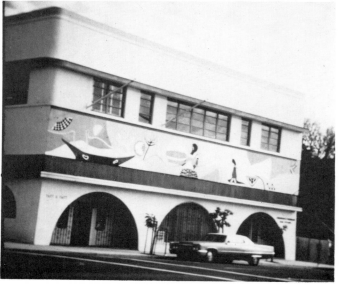

(Top)
A glass mosaic mural, repeating the colors used in mosaic exterior designs, has been incorporated into the original plan and construction of this school's central corridor. Courtesy of Carthage Central School, Carthage, New York

(Bottom)
High-school students painted this mural, carefully designed and placed to harmonize with the building structure. Courtesy of People's High School, Vallejo, California

Embellishing with Murals

Most school buildings, old or new, that lack integrated art forms have areas which could be turned into aesthetic focal points. Corridors, exterior walls, doors, cafeterias, and meeting rooms contain surfaces receptive to mural materials. All that is needed are imagination and a little extra effort to turn a drab, institutional-type area into a bonanza of color and design.

How should one begin? A perceptive eye is required, and it usually belongs to an alert teacher, art consultant, or concerned administrator who can see the need for a mural and find a spot where it can grow. Before definite plans can be formulated, however, certain procedures need to be followed. First, the school principal must give his or her approval. Usually this presents no problem, because any positive improvement to one's own school is readily acceptable. Second, the authorities in charge at the main district or county school office need to sanction the project. These may include the superintendent or his or her assistants as well as the head of the department of building maintenance and operations. If this happens to be the first undertaking of the kind, and guidelines do not exist, they should be formulated immediately. Guidelines for future, similar endeavors will then be established, avoiding future misunderstandings that could abort a building project. Certain required procedures should be included in these guidelines. When a project proposal has fully satisfied the procedural questions, it must be submitted to a qualified person or persons for final approval. These usually include the art consultant or coordinator, the school principal, and one or two representatives from the central office. A project proposal might specify the following:

1. A preliminary sketch of the proposed project. (First attempts should be simple.)
2. Detailed information concerning the selected area, including surface, obstructions, and available space.
3. Types and approximate quantities of materials to be used, costs and sources of funds.
4. Proposed number of days and hours of production, with a tentative completion date.
5. The name of the person responsible for supervising the total process.

Serious problems are not likely to occur if these procedures are followed carefully. And the time and energy expended in such preparation will increase the chances of the project's success.

Although processes of mural making were discussed previously, remember that a thorough study of the site relative to the media to be employed must be made by the students and teacher before final planning. If the selected space is a smooth wall, no problems should exist. But, what if the area is cluttered with school bells, wall clocks, pipes, drinking fountains, doorways, fire-alarm boxes, and fire-extinguisher niches? Appreciate them rather than deplore them, for they present a genuine challenge to the creative spirit. Consider the many ways they can be incorporated into the whole mural design, or perhaps the manner in which the design can be adapted to accommodate the extra clutter. Students have solved these problems in the past by transforming a round hall clock into the head of a lady bug, the sun, or the center of a flower surrounded by colorful petals. Pipes have been converted into stems or vines with added leaves, or they have been painted to become decorative lines as part of the general picture. In fact, some of this equipment can be used to a definite advantage, augmenting the feeling of the total mural.

Before actual work begins, all plans should be checked thoroughly. In addition, the students should be able to give reasonable answers to these questions:

1. Will the mural be appropriate for the selected site and for those who will view it? (Obviously there will be differences in concept depending on whether the project is to be placed in a cafeteria, band room, hallway, or on an exterior wall at the building's entrance.)

2. How permanent will the mural be? Is it to be the gift of a specific class to be painted over in a year or two by another class? Or is it planned to be a fairly permanent part of the building? (Remember that the term "permanent" is relative and that eventually all things change.)

3. Will the subject and/or the style of the mural offend anyone?

4. Is the topic worthy of the time and effort involved in putting it into as permanent a form as the mural suggests?

61

A direction and information mural, indicating the location of public telephones, was painted by high-school art students on an adjacent flat wall. Courtesy of Duarte United School District, Duarte, California

Another high-school student-painted telephone design uses the recessed space as part of the total composition. Courtesy of Los Angeles Unified School District

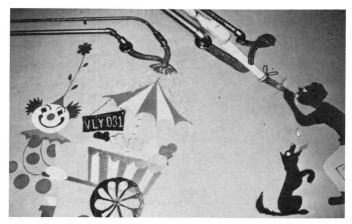

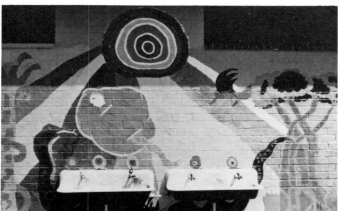

(Top, left)
A school bell on the wall has become part of the body of a butterfly in a garden of flowers, as conceived by elementary-school children. Courtesy of San Francisco Unified School District

(Bottom, left)
A school wall clock created into a sun. Courtesy of San Francisco Unified School District

(Top, right)
Wall pipes integrated into a picture. Courtesy of San Francisco Unified School District

(Bottom, right)
An outdoor drinking fountain is now part of a fantasy landscape. Courtesy of Glendale Unified School District, California

A striking mural illustrating a pleasant rhythmic design has been developed by thoughtful placement of the trees. Courtesy of Vista High School, Vista, California

After the wall surface has been washed and prepared in whatever way is necessary, basic forms may be blocked in. A drop cloth or some type of floor covering, possibly newspapers, should be placed down for protection, and masking tape should be used to prevent work from going beyond the designated limits. When everything is organized and ready, the business of mural making begins. Throughout the entire process, it is vitally important that frequent reviews or evaluations take place to determine the need for changes or slight adjustments, realizing that every portion must be viewed not only in relation to adjoining areas, but to the completed whole.

Whenever practical, materials and equipment should be cleaned and put away in a safe place at the end of each work session. This will make it easier for others using the area, will discourage unwanted vandalism, and also will be important psychologically to the artists as they start afresh with each production period.

Although the organization, preliminary details and ongoing clean-ups may appear superfluous to the students eager to get on with the project, they are important to the quality of the mural. When the final work is viewed with that special feeling of satisfaction that only those involved will understand, all of the time spent in extra details will have been justified.

Special Conditions for Mural Making

There are circumstances where students might need special help in mural making. Among these would be classes or schools for handicapped or exceptional children. These young people also should be given an opportunity to embellish their buildings. A cooperative endeavor can be arranged with students from other classes or from different schools to help handicapped students. This is not only a workable approach but is also of positive value to both groups. It can be a tremendous learning situation and a very satisfying experience to the helpers. And the recipients have the knowledge that they have made a valuable contribution to their school through their own efforts with the help of new friends.

Accepting only a minimum of assistance from others, trainable mentally retarded children painted a simple but happy mural for their school. Courtesy of Bakersfield City School District

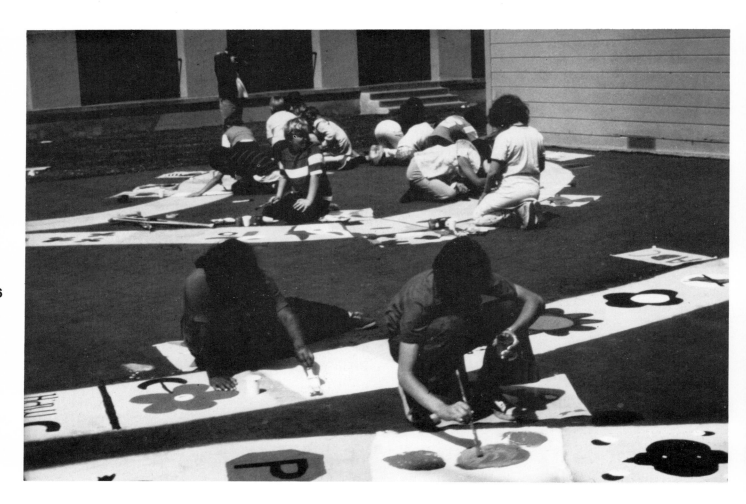

Sixth-grade students painting the kindergarten tricycle path from the
designs they developed themselves. Courtesy of Bakersfield City
School District

Many special children are capable of developing their own designs by creating them on large pieces of paper. Sometimes cutting out the shapes to be traced on the wall surfaces may require a little assistance from others, but the art work will be essentially their own. And their pride in their accomplishment will be more valuable to them than the mural itself.

Playground Painting

A natural spin-off of mural-painting activity is the decoration of playground asphalt areas. Colorful designs have been executed on asphalt running tracks, tricycle paths, and hopscotch and other game areas, adding a new dimension to many school yards. Because of the heavy wear on a playground's surface, the life span of such a project is approximately two years, although some have lasted as long as four or more. A good undercoating of white paint on the asphalt will not only increase the mural's wearing qualities, but will also make it easier to develop and paint the final design. Acrylic paint is excellent for this purpose and should be used full strength.

Lanes of different colors separate these runners on a painted asphalt school track. Courtesy of Los Angeles Unified School District

The Graffiti Problem

Occasionally school murals are implemented for additional reasons besides beautification. They might be developed to cover graffiti or to protect an area from being marked up. Blank walls, especially those in less easily supervised spots, are tempting to the graffiti artist. One method of overcoming the problem is to offer students another means of expression. They can be provided with opportunities to make an area more appealing to all by putting down their own ideas in a visually attractive form. Experience has shown that the covering of graffiti with designs by willing students under the guidance of concerned adults has been a successful means of dealing with this problem. And the same young people responsible for the graffiti could be those who willingly wish to involve themselves in the production of handsome murals. A revealing bit of information is that these art forms rarely are defaced maliciously. The artists' feelings of successful accomplishment are such that they would not think of harming their murals. Nor would they permit their friends or rivals to touch their work.

(Left)
Graffiti sprayed on the inside hall of a high-school building. Courtesy of Los Angeles Unified School District

(Right)
A block-long school retaining wall has been defaced by graffiti. Courtesy of Los Angeles Unified School District

(Opposite)
The same retaining wall after murals were painted on it by the students. No graffiti is evident. Courtesy of Los Angeles Unified School District

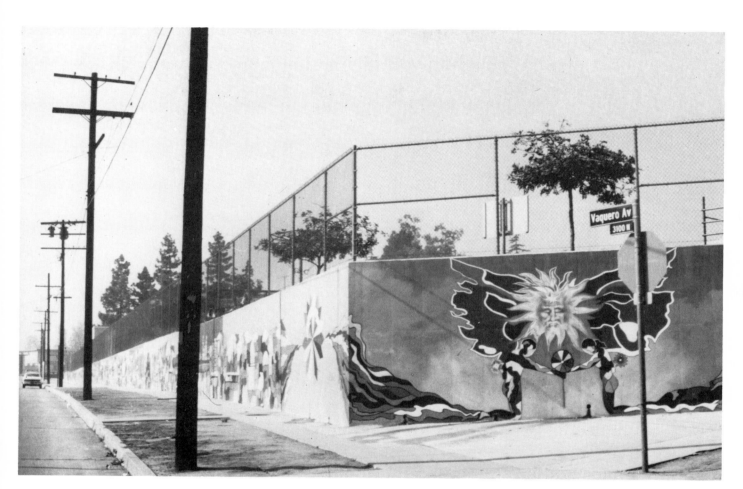

A mural project should result from students' thinking and efforts. If outside artists are brought to the school site to create wall designs for pupils to fill in without giving them the opportunity to provide some input in the design planning, problems may arise. Capable students might feel that they have been reduced to the level of laborers, painting by numbers the visual statement of another. Their pride in their personal creative ability is squelched when they feel that their ideas are not worthy of permanent mural status.

If a school building is embellished as a natural outgrowth of classroom art activities or pupil planning, something special happens. The magical transformation of original sketches into a colorful mural becomes an electrifying experience for both the artists and spectators. As the work is completed, students' interest is quickened, their self-images increase, and school pride grows. These three results seldom vary, and—not so strangely—vandalism usually is no longer a concern. A natural result of creative accomplishment is self-respect. This is an important facet of the learning process, and is the basis of education as well as the reason for school buildings existing in the first place.

A high-school student helps to transform a graffiti-covered corridor wall into a colorful area with his attractive mural. Courtesy of Los Angeles Unified School District

Chapter Seven

Improving the View

People are born decorators, from earliest times having embellished themselves with tattoos, body painting, jewelry, and colorful wrappings. They have adorned their dwelling walls or those of their gods in an attempt to continue to satisfy this decorative urge. Whether they built structures from hides, wood, clay, or stone, they painted or carved ideas and events important to them on these structures—and people still do.

But recently, new trends have been developing. An abundance of large-scale art has been thrust on the public differing from murals of the past in character and boldness. Perhaps some of it evolved out of the movement of the 1950s and 1960s toward producing large-sized paintings. In their desire to make more colossal statements about their times, some of them moved outdoors to turn exterior walls into giant canvasses. A colorful example is a large abstraction painted on the facade of a six-story building in the Greenwich Village area of New York City. It is one of many appearing everywhere. They range in style from nonobjective to illustrative, and the quality of work is just as diversified. This direction may have been spurred by the Civil Rights movement, which helped to popularize the idea that art belongs to all people.

Artists no longer aspire to confine their efforts only to galleries, museums, and private collections—they want it to be accessible to all.

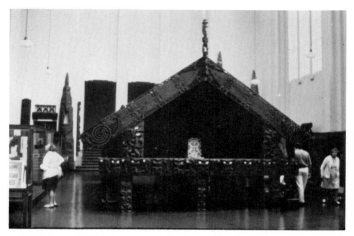

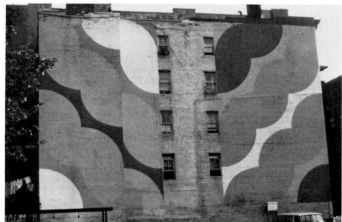

(Top)
The Maoris of New Zealand decorate their wooden homes with intricately carved figures. The War Memorial Museum; Aukland, New Zealand. Photograph courtesy of Al Dennis

(Bottom)
This large, abstract painting faces a New York University apartment complex.

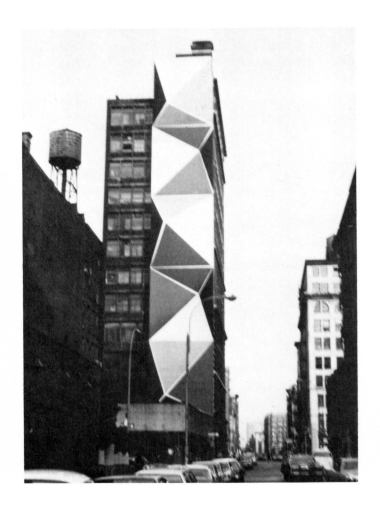

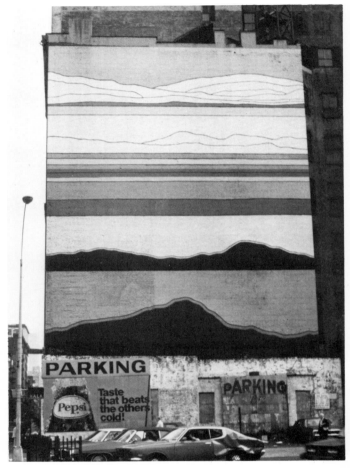

(Left)
A colorful design on a New York building creates the illusion of three dimensions.

(Right)
An abstract mural on a Greenwich Village building.

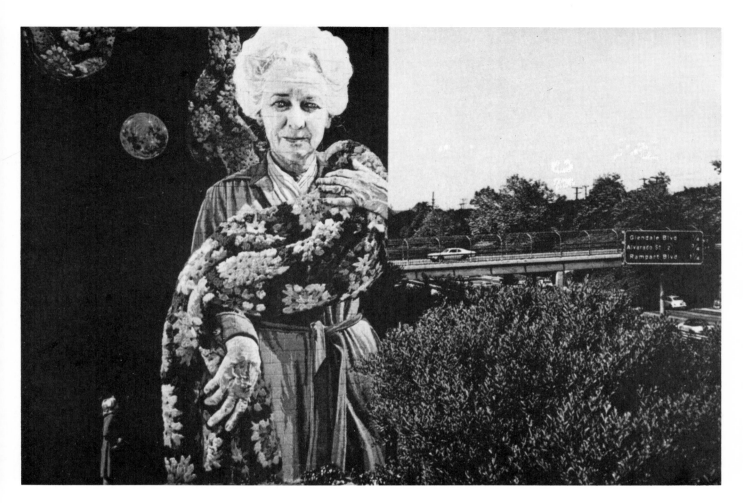

73

This portrait of actress Lillian Bronson was painted by artist Kent Twitchell as a tribute to the elderly. It is thirty-feet high, covering the side of a building, and is viewed by more than a million motorists a week who traverse the north bound Hollywood Freeway in Los Angeles. Courtesy of Kent Twitchell, Hollywood, California

An Alternative to Graffiti

Outdoor murals have their origin in other phenomena as well. They have also become an answer to the graffiti problem. When the graffiti have been covered by brilliantly colored designs in the form of a mural, aerosol-paint vandalism has appeared to lessen. Graffiti have been with us since the beginning of history. Obscenities were scrawled on the walls of ancient Rome, the ubiquitous "Kilroy was here" made its appearance during World War II, and furtive writings, quietly announcing a name, loudly shouting vulgarities, or imparting bits of humor, have been visible in public restrooms for years.

Studies have been made concerning the causes of the problem with differing results. Graffiti seem to be more than painted symbols. They are an extension of human personalities demanding recognition. Some give identity to gangs staking out a territory. Others attempt to communicate, amuse, kill time, deride, or give vent to frustrations. A small number present positive messages, emphasizing moral values. Although most graffiti are unattractively scrawled at random, a few are rather attractively designed.

A Community Mural Program

Communities, especially in inner cities, have attempted to work with graffiti artists by involving them in more constructive mural programs. An example of a successful project is the one developed in a government housing project in East Los Angeles. Soon after the buildings were completed, they became run down and dingy. Spray-can graffiti covered most of the available wall space. As the apartments lost their attractiveness, the residents seemed to lose their pride.

However, a young artist who had been working with some of the teenagers living in the housing development, many of whom belonged to the same gangs responsible for the graffiti, realized that these "decorators" could replace their random handwork with something more attractive if given a chance. The artist therefore organized a painting program on the building grounds. Authorities granted permission to paint one wall. The design chosen was a combination of ideas presented by the teenagers and coordinated by the artist-director. As the graffiti disappeared and color spread across the area, the total environment began to change. The residents became interested, and everyone wanted to participate. Pride in accomplishment was contagious.

A major drawback was the lack of funding, even though approval to work on more walls had been given. A paint-manufacturing company was approached, and its educational director immediately realized the value of the undertaking. He provided a supply of paint to the group. After the success of the first murals, the Los Angeles City Housing Authority became so convinced of the importance of the project that it provided money to continue the mural painting on the forty buildings within the housing project.

Subject matter ran from an emphasis on Mexican culture and social concerns, to abstract art. School children, mostly young teenagers, did the painting, but all of the local inhabitants seemed to be involved, if only to provide moral support. Those too small to actually paint carried buckets. Those too old or hesitant about their talent moved scaffoldings or cheered the others on. At times the age span was from three to seventy years. Each arrival of the artist-director on the grounds brought enthusiastic cries of "When are we going to paint?" It was an involving project that captured the interest of everyone.

The original idea mushroomed into a "paint-up, cleanup campaign" beyond imagination. During the first summer program, 130 young people participated. A happy spin-off occurred when a talented teenaged resident received a full scholarship to a trade and technical school as a result of his mural at the housing project.

Graffiti all but disappeared from the housing project. Why wreck something beautiful? Besides, it was found that a member of one group would not dare to deface the art work of

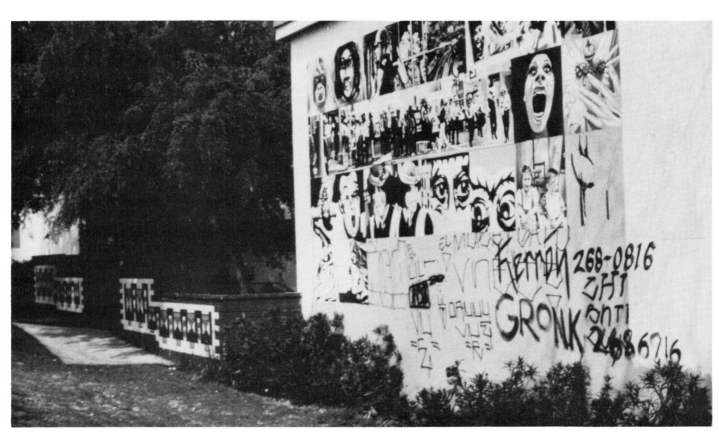

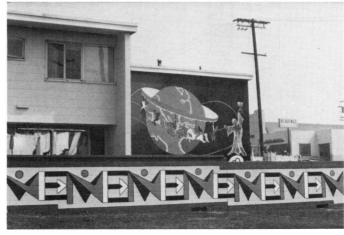

(Above)
Courtesy of the Estrada Courts Housing Development, East Los Angeles

(Right)
An abstract design painted on a low wall contrasts with a large mural of children, representing all races, circling the world on a carousel. Courtesy of the Estrada Courts Housing Development, East Los Angeles, under the direction of artist Charles Felix

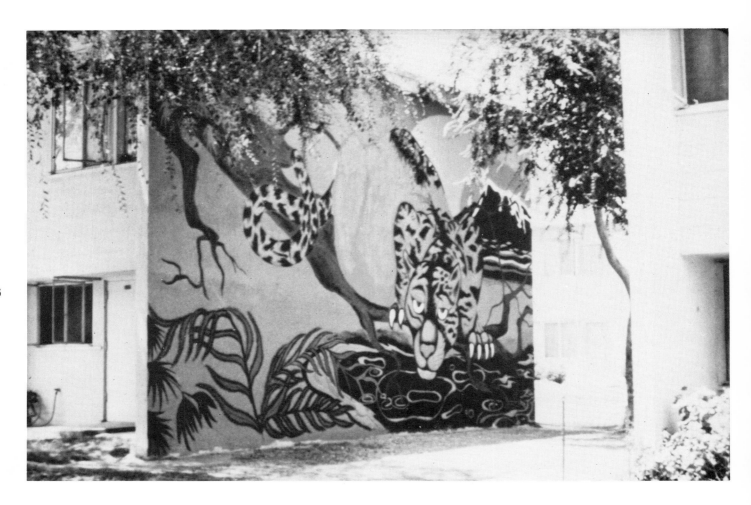

Courtesy of the Estrada Courts Housing Development, East Los Angeles

someone in a rival group for fear of starting a gang battle! Surface after surface was painted over with murals, and no unwanted graffiti appeared. The atmosphere had never been so pleasant, and building maintenance costs dropped.

The value of this particular project far exceeded the murals themselves. Of great importance was that the young painters kept themselves out of trouble during the summer and after school. They were participating in a purposeful activity that they enjoyed. A large number of these young people were known as "problem kids" in school. This was difficult to believe after seeing their work. Although mural painting has long been a popular classroom activity, this community effort brought a renewed and catching enthusiasm to the students who carried their interest back to the schoolroom. And the walls of local institutions of learning received new and colorful paintings.

An important by-product of the afternoon paint project was that working on these murals acted as a character reference for any teenager applying for a job elsewhere. Doors that formerly had been closed suddenly were opened. A new self-image was developing for these youngsters as art became increasingly significant to them. Some chose it as a vocation when local business people made arrangements for these artists to paint murals on the walls of their establishments. Not only had art become important in beautifying a drab housing complex and brightening up a local community, but to many of those involved it had become a new way of life.

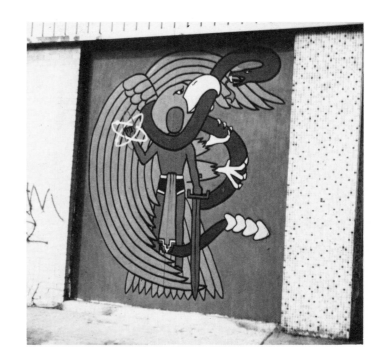

The first of three beautification murals planned to overcome graffiti problems in East Los Angeles, financed by a special grant from the city.

*A local business-person's building was defaced by spray-can mark-
ings until he hired a young housing project muralist to decorate it.
Mural by Willie Herron, East Los Angeles*

A wall in Central Los Angeles. Subject matter varies according to the wishes of the individual artist in much of the street art that is not specifically commissioned.

Sources of Funds for Mural Programs

Although the East Los Angeles housing project is only one example, it is typical of many. And the housing development mural projects have continued to spread into the street. Artists have combined their talents to paint store fronts, retaining walls, freeway supportive structures, and any available public or private surface. A few work alone, financing their own efforts. But most, both individuals and groups, seek the support

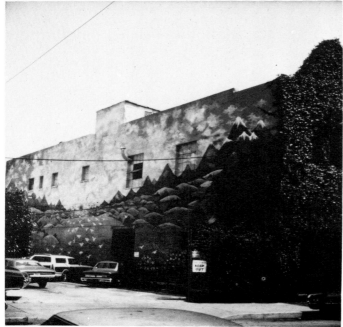

(Top)
A wall in Westwood, Los Angeles.

(Bottom)
An office building in Los Angeles painted by a group of students under the direction of Barry and Yosha Finch.

of patrons such as business people and art galleries. The growth of colorful outdoor murals has supplied the incentive for local people to get busy, changing neighborhood wastelands into grassy parks. As a consequence, run-down areas have been rejuvenated, pride has grown in neighborhoods that had known dejection, and everyone benefited.

The Comprehensive Employment and Training Act (CETA) is another source of funds for muralists. It has replaced the Work Projects Administration (WPA) of the 1930s in the use of federal jobs dollars to subsidize the arts. Through multibillion-dollar programs in the late 1970s, the United States Government began underwriting the coast-to-coast mobilization of thousands of unemployed artists. Some were actors, dancers, and musicians, but many were visual artists who became part of mural programs backed by CETA dollars. Chicago has been one of the pacesetters in the use of this federal money to support the arts. As a result, walls now glow with colorful murals. Other cities also have been able to experience a renaissance of the arts through CETA funds. And a direct consequence of this renaissance has been the creation of visually stimulating murals in areas where they could not have appeared without such help.

The National Endowment for the Arts provides grants to individuals, organizations, towns, cities, state arts agencies, and many others. The Endowment has published information explaining the many grants available. This is sent, free of charge, to those requesting it from the NEA Program Information Office, Mail Stop 550, Washington, D.C. 20506. Additional government funding, both state and federal, is available through various Arts in Public Buildings programs. Banks, oil companies, and other large corporations have established foundations that provide financial aid to mural artists who qualify. Our nation has become acutely aware of the need for the arts in the environment. Citizens everywhere have become the beneficiaries, both as practicing artists and as active viewers.

Positioning Street Art

Thoughtful positioning of street art is important. Unfortunately, there are a few examples of improper placement that are bad for the artist as well as for the viewer. Certain points should be

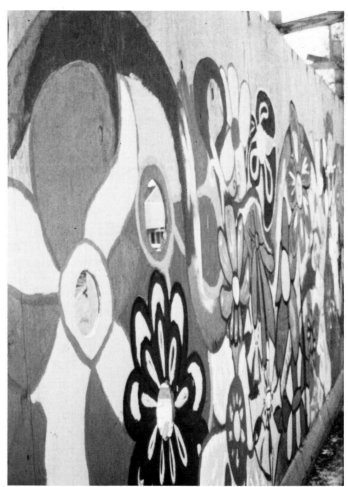

considered. Who will see it? When? And how? Will it be placed on a wall within a confined area, or in the open where it will be viewed by pedestrians and motorists? Will it be clearly visible without being partially obscured by trees, poles, and miscellaneous objects? Can it be seen from a distance as well as from the immediate area? Above all, is its placement adequate enough to justify the work necessary to create it?

(Left)
Courtesy of Chuck's, Westwood Village, Los Angeles

(Right)
A close-up of the temporary fence showing cutout flower centers, serving as ''sidewalk superintendent'' observation stations through which the construction activity may be watched. Mural by Bakersfield City School District students for the Bakersfield City Police Department

Murals of a temporary nature are important, too. Many building-construction sites are surrounded by board fences for protective as well as for aesthetic reasons. These provide excellent mural-painting surfaces. The opportunity usually awaits any group wishing to submit a plan to paint these fences, especially school children. The owner of the structure, the contractor, and, if it is a civic facility, local officials should be contacted to approve the project. Often local service clubs will donate the paint, since city well-being is one of their concerns. These murals are of short duration with a maximum life of approximately one year, but they still need to be organized carefully to ensure reaping the awards of satisfaction in terms of community enjoyment.

Another type of street painting is the mobile mural on the sides of vans and trucks. Many of these are noncommercial designs, though a few display some type of club insignia. The majority are embellishments to please the whims of the owners. Some consist of original realistic or abstract paintings. Others are giant decals. However, all speak of the urge to decorate that seems to be a part of the vast outdoor art movement.

Although some wall paintings on buildings serve the owner as a type of advertising, they are unique in concept and are not to be considered in the same category as commercially produced billboards and signs. True, the line of demarcation is very thin, and it is sometimes difficult to determine what is a true mural. But much of the street art, especially in ethnic communities, bespeaks social concerns and national history, and is a monument to the struggles of their people. Others are fanciful and whimsical decorations that help to brighten an area and camouflage ugliness. Of great importance is their showing the need for more positive recognition of the artist.

82

(Top)
German school children painted colorful figures on a temporary fence surrounding a construction site in downtown Munich.

(Bottom)
A movable mural applied to another aspect of contemporary life.

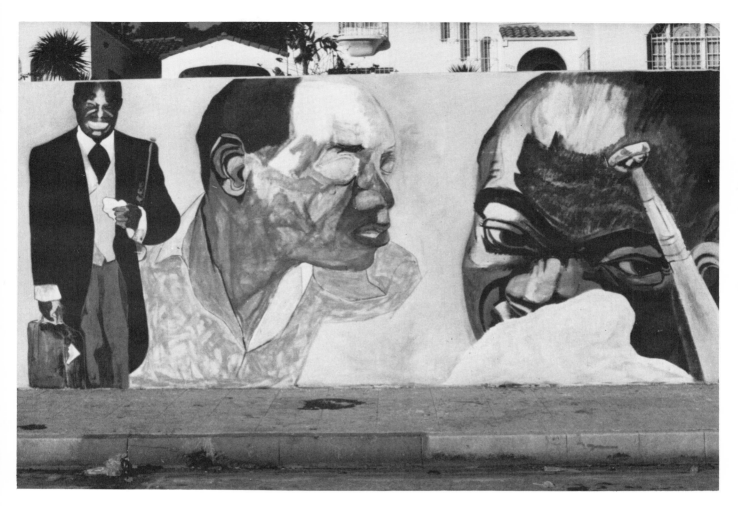

A strong social statement is made in this mural on a busy street in an ethnic community of Los Angeles.

(Above)
A powerful design by Barbara Pelochino appears on the exterior wall of a drug store. Mural sponsored by the City of Hawaiian Gardens, California

(Opposite)
An abstraction of a caduceus was developed into a mural of marble, tile, and brick by artist Fran Williams. It was commissioned by the builders of a medical building and designed to coordinate with its facade. Courtesy of the Kendall Medical and Professional Buildings, Florida. Built by Eugene Fleischer and Edward Grad of Mark XX Investment Corp., Miami, Florida

A Final Word

As street after street blooms with color, one might ask, "How much is enough?" This and many other questions that may arise from it demand thoughtful consideration to preserve both the free, creative spirit of the artist and the rights of the public viewer.

The lessons of the past have helped us become aware of the value of murals in providing attractive surroundings. From them we have learned about the methods and problems faced by the makers of murals throughout history. It is hoped that we may continue to improve our environment by creating murals through inspiration of ideas, knowledge of media, understanding of the art language, and sensitivity to the world around us. And, in so doing, perhaps we shall be able to improve the quality of life for all.

Rainbow Tank, *mural on gas storage tank by Corita Kent. Courtesy of the Boston Gas Company, Boston, Massachusetts*

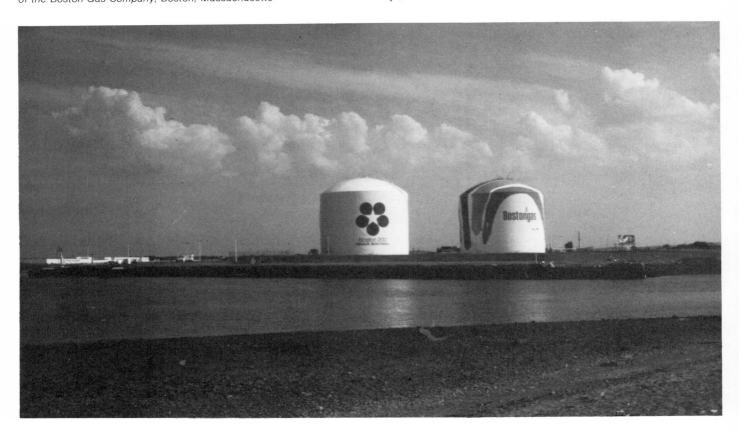

Index